A Gallery of Presidents

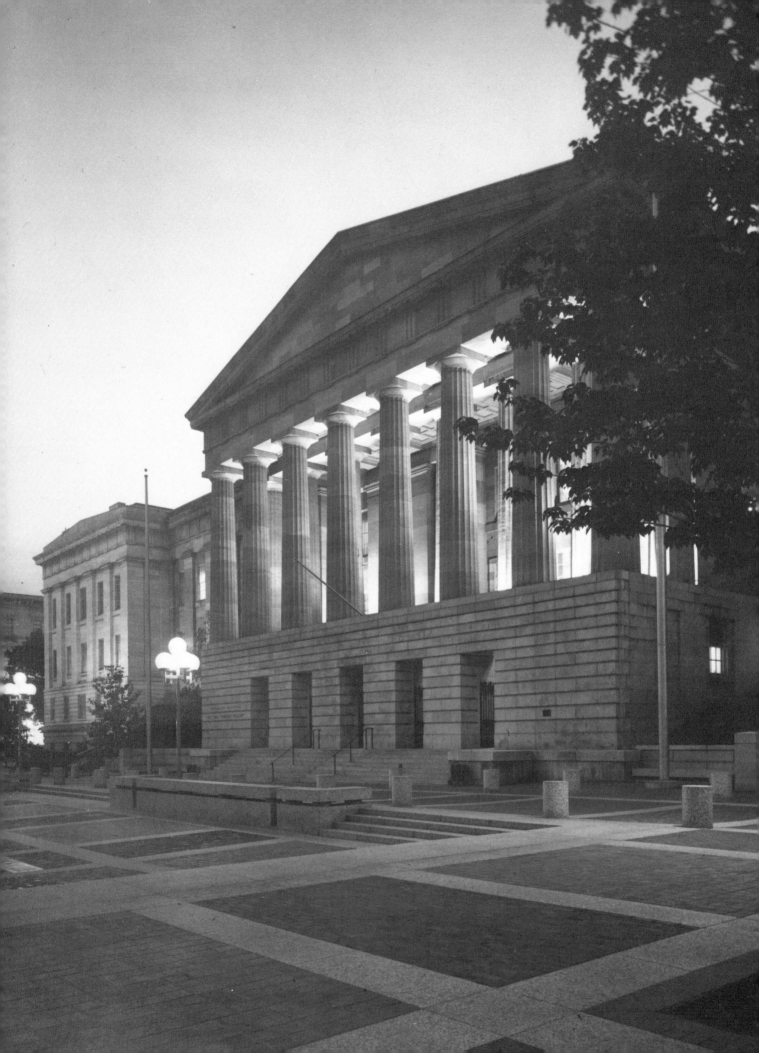

A Gallery of Presidents

MARC PACHTER

Historian, National Portrait Gallery

Published for the National Portrait Gallery

by the Smithsonian Institution Press

City of Washington 1979

Cover: Hall of Presidents in the Smithsonian Institution's National Portrait Gallery
Frontpiece: National Portrait Gallery. Photograph by Robert C. Lautman
Photograph of Gerald R. Ford courtesy of the White House

Library of Congress Cataloging in Publication Data

National Portrait Gallery, Washington, D. C. A gallery of presidents.
1. Presidents—United States—Portraits. 2. Portraits, American.
3. National Portrait Gallery, Washington, D. C.
I. Pachter, Marc. II. Title.
N7593.N23 1979 704.94′23′09730740153 78–22471
ISBN 0–87474–743–0

Contents

Foreword

The portraits of the presidents reproduced in this volume from the original works in the National Portrait Gallery are not only the products of the artists who created them, but, like all portraits, of the individuals who posed for them as well. Apart from the question of the physical attributes of the subjects, if certain of the artists represented here were not equal to their task, it also cannot be overlooked that certain of our presidents were not equal to theirs. Unfortunately, these two elements do not always coincide in the proper proportions. Yet, if artistic style and presidential substance are not perfectly synchronized with one another here, the truth has not been badly served.

Marvin Sadik, *Director*
National Portrait Gallery

A Gallery of Presidents

George Washington

1st PRESIDENT 1789–1797

George Washington brought the gift of his cast-iron character to the turbulence of American revolutionary and early national life. "This Vesuvius of a man," as a biographer described him, who was threatened always by the eruption of his own fierce irritability, achieved a serene and compelling dignity of presence which portraitists transformed into the very image of republican majesty.

In 1796, when Gilbert Stuart painted this portrait of presidential calm, he falsified the moment but caught the mood of the age. Washington, who had been the nation's unanimous choice for commander of the army, for president of the constitutional convention, and twice for president of the United States, was at that moment harassed, in his last full year in office, by the opposing claims of the Hamiltonians and the Jeffersonians and by the controversy surrounding John Jay's treaty with Great Britain. Stuart, however, portrayed the Washington who endured to become the symbol of national permanence above the squabble of politics.

Gilbert Stuart painted this celebrated "Lansdowne" portrait in his Germantown, Pennsylvania, studio in 1796. It was commissioned by William Bingham, United States senator from Pennsylvania, and his wife, for the Earl of Shelburne, later Marquis of Lansdowne, who had defended the rebellious colonies in Parliament.

GEORGE WASHINGTON
Gilbert Stuart
oil on canvas, 1796
244 x 152.5 cm. (96 x 60 in.)
Lent by Lord Rosebery L/NPG.68.19

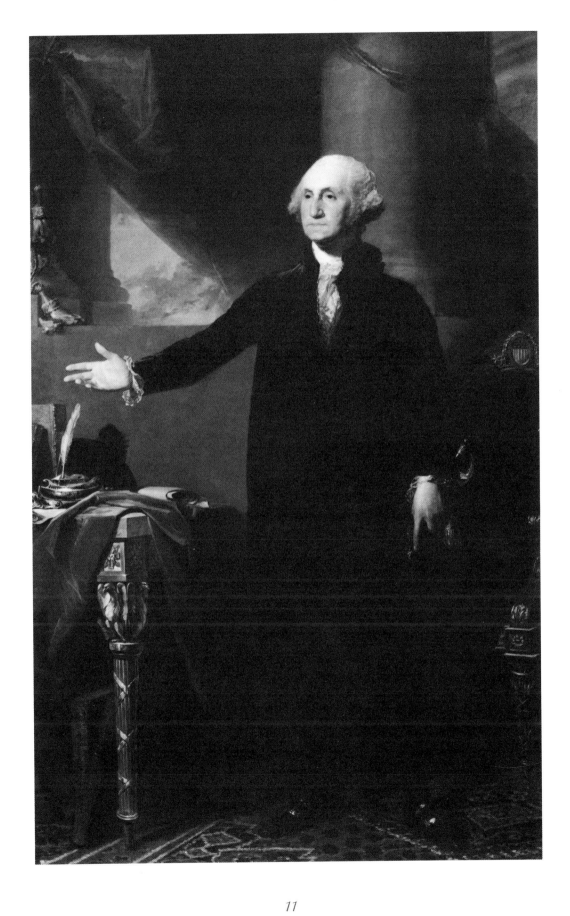

John Adams

2D PRESIDENT 1797–1801

John Adams, as John Trumbull painted him in 1793, caught up in his thoughts and ambitions, was then in his awful hiatus as the new republic's first vice president. "My country," he wrote to his wife, Abigail, "contrived for me the most insignificant office that ever the invention of man contrived or his imagination conceived." It was an intolerable situation for a man whose passion and intellect had provoked revolution in the Massachusetts of the Sugar and Stamp Acts, and in the continental congress where he had implored, cajoled, and bullied reluctant members into declaring independence.

Universally respected for his integrity, and disliked at one point or another by nearly everyone for the self-righteousness which underlay it, Adams finally escaped his vice-presidential entombment when he became, by three votes in Congress, the country's second president. The heroic figure of Washington was poorly replaced in the popular imagination by the short, stocky Adams—"His Rotundity" to those who resented his insistence upon the trappings of office.

Adams, like his predecessor, resisted strong partisanship, but he never seemed so much above as beside the fray, infuriating both the Jeffersonians and the Hamiltonian Federalists with his independent judgment and disposition to act alone. Abandoned by the Federalists, he left office in 1800 for his books, his writings, and a splendid political isolation in his native Massachusetts as "the Patriarch of Braintree."

JOHN ADAMS

John Trumbull
oil on canvas, 1793
76 x 63.5 cm. (30 x 25 in.) NPG.75.52

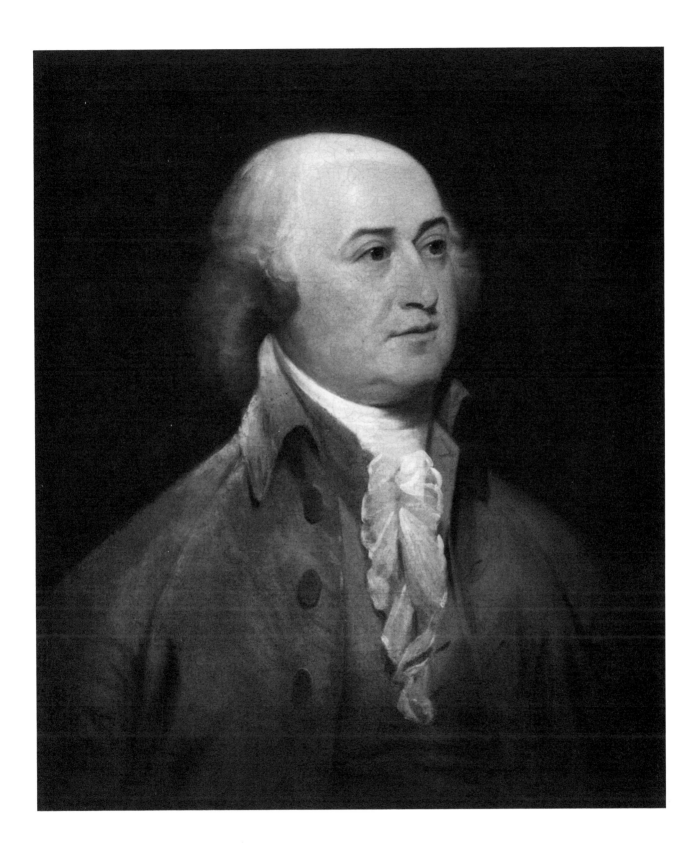

Thomas Jefferson

3D PRESIDENT 1801–1809

In 1819, when the Italian-born artist Pietro Cardelli approached Thomas Jefferson to do his portrait bust (of which this is one of the few extant casts, made about 1910), the "Sage of Monticello" was a living monument to past glories but not yet a spent force. Then in his seventy-sixth year, Jefferson was engaged in what he believed to be—along with the Virginia Statute for Religious Freedom and the Declaration of Independence—one of the three great accomplishments of his life: the creation of the University of Virginia.

More than modesty led Jefferson to exclude his presidency from a final assessment of his career. Although he registered, during his term of office, the breathtaking success of the Louisiana Purchase, Jefferson feared that he had strained the Constitution by bloating the domain of a federal government whose growing power he feared, and was uneasy, too, about his role in the creation of the factitious American political party system.

A shrewd and sometimes vindictive politician, Jefferson held tenaciously to his vision of the enlightened human spirit throughout the inconsistencies of his public career, and retired willingly at the end of a second presidential term to the peace and solitude of his estate at Monticello. There Cardelli found him, a philosopher of education creating the foundation of a moral commonwealth.

THOMAS JEFFERSON
Pietro Cardelli
plaster, cast after the 1819 original
57.5 cm. height (22⅝ in.) NPG.72.108

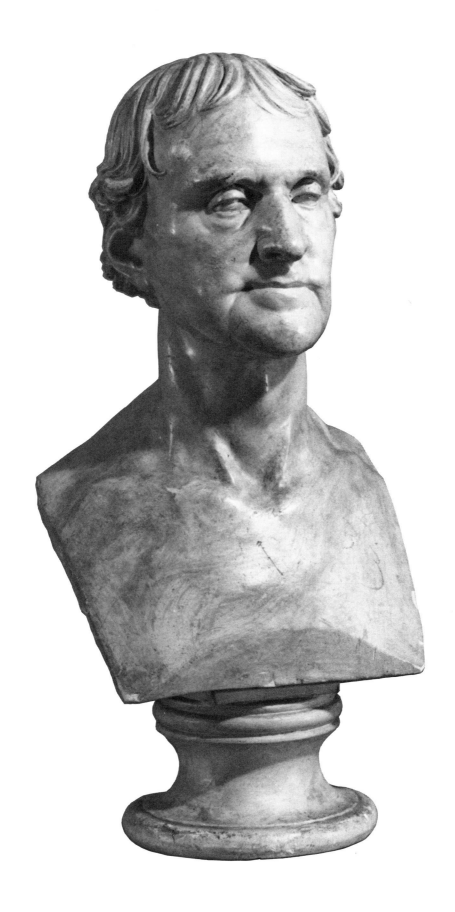

James Madison

4TH PRESIDENT 1809–1817

There was nothing commanding about James Madison's appearance. His slight, gaunt figure, invariably dressed in black with the occasional relief of buckles, gave the impression of a retiring, philosophical spirit poorly suited to political combat. But Madison exercised, through the strength of his will and intellect, an overwhelming influence in the arena of revolutionary and federal politics. Ubiquitous in the 1787 debates to create a durable union, he became the master builder and preeminent defender of the Constitution as an original and effective design for government.

Madison's subsequent career, first as an influential congressman and then as Jefferson's secretary of state, led inevitably to the presidency. But there he nearly foundered. Harassed by the French and British provocations against American commerce, and by the chaotic hostility of a Congress divided against itself and against the feeble military establishment, he embarked upon the uncertain administration of war. "Mr. Madison's War," as it was known to his enemies, began badly with a series of disastrous campaigns and with the political revolt of New England, but was salvaged in the final months by a number of impressive naval and military victories.

Described in the course of the war as looking "miserably shattered and woebegone," Madison later regained his popularity and went on to an increasingly successful administration, made stylish by his lively wife, Dolley, and productive through his program to build the authority of the national government. As his presidency drew to a close in 1816, Madison celebrated the "peculiar felicity of this constitution" which had proven itself equal to his ambitions for the expanding nation.

JAMES MADISON
Unidentified artist
oil on canvas, circa 1825–1830
76 x 63.5 cm. (30 x 25 in.) NPG.68.50

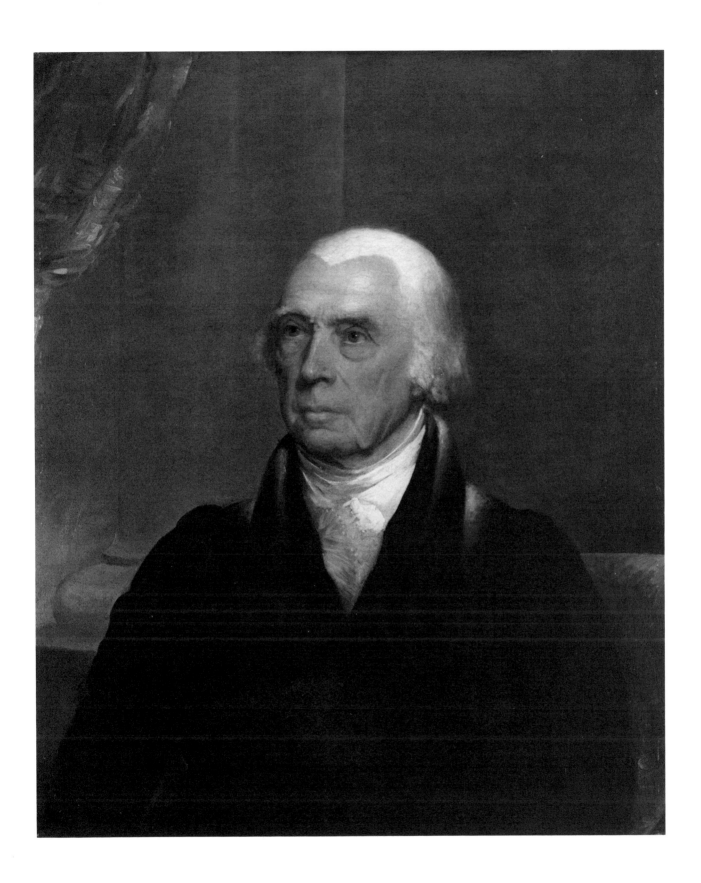

James Monroe

5TH PRESIDENT 1817-1825

As President-elect James Monroe sat for this portrait in November of 1816, he had reason to feel great satisfaction. His long-fought struggle for the presidency, begun some nine years earlier, was finally over. In time, he would enjoy near-unanimous election to a second term.

Monroe's elegant sobriety, wonderfully described by his French-trained American portraitist, John Vanderlyn, suited the new country's rise to full national dignity. Formerly a strong regionalist and a narrow partisan of the Jeffersonian Republicans in their struggle with the Federalists, Monroe presided over an era of political peace and in time promulgated his great doctrine of the territorial integrity of the Americas. In his person and in his policy, he epitomized the consolidation of the United States and its cosmopolitan assertion of rightful place in the society of nations.

JAMES MONROE

John Vanderlyn
oil on canvas, 1816
67.5 x 57 cm. (26½ x 22⅜ in.) NPG.70.59

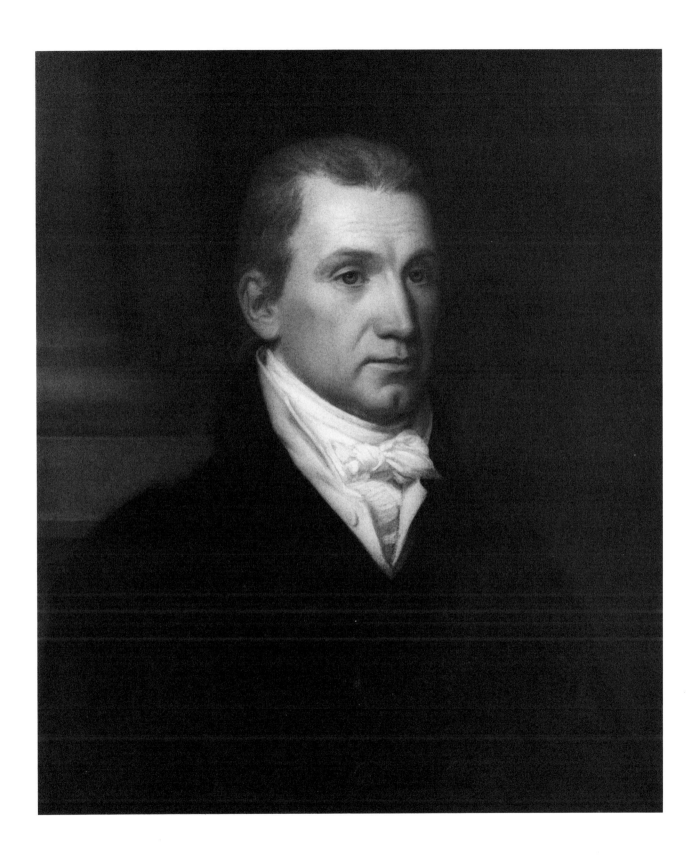

John Quincy Adams

6TH PRESIDENT 1825–1829

John Quincy Adams deeply wished that his many portraitists would paint him as he truly was rather than as he looked. Throughout his life he felt himself an inwardly passionate and even warmhearted spirit locked within a frozen exterior. But locked within it was, and his portraitists caught excellent likenesses of the public man: the loner, the strong-willed spokesman for principle, the prickly combatant whom Emerson delighted to call "no literary gentleman but a bruiser [who] loves the melee."

Veteran of a brilliant career as diplomat and Monroe's secretary of state, survivor of a politics-scarred presidency, and finally, until his death, a triumphant defender of civil rights in Congress, Adams never settled into sweet venerability. Painted here by George Caleb Bingham, perhaps with the assistance of a daguerreotype, in his seventy-seventh year, he maintained the look and habits of an austere and dedicated man whose emotions surfaced only as moral intensity.

JOHN QUINCY ADAMS

George Caleb Bingham
oil on canvas, circa 1844
76 x 63.5 cm. (30 x 25 in.) NPG.69.20

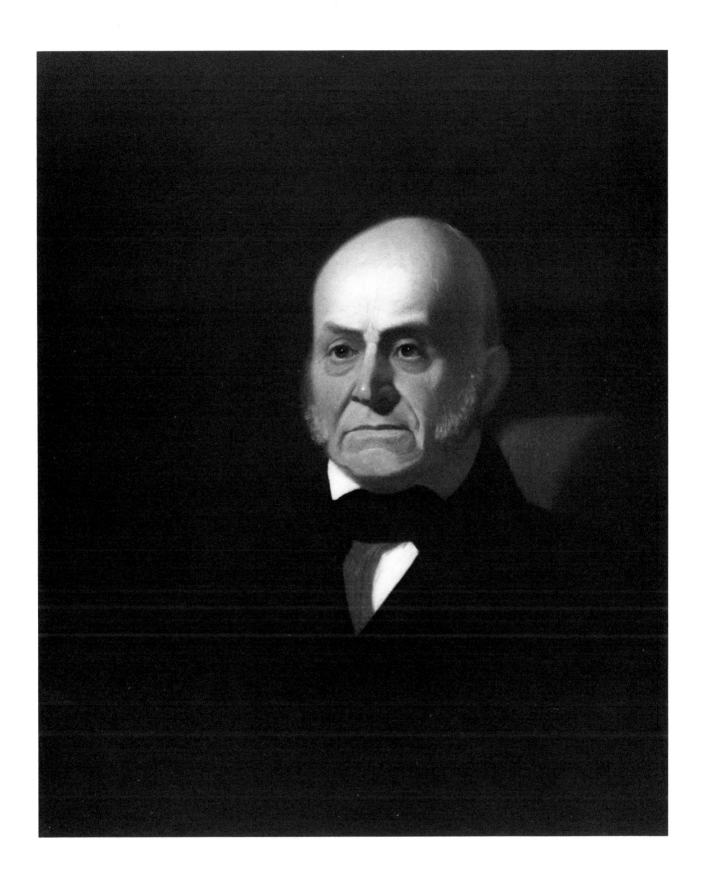

Andrew Jackson

7TH PRESIDENT 1829–1837

It might have been vanity which prompted Andrew Jackson to take on as his resident portraitist Ralph E. W. Earl, who called himself "the King's Painter." But Earl's lifetime commission was justified by the constant demand for images of the old general. Jackson was a genuine folk hero, worshipped by the people as one of their own and as a symbol of the best they might become.

The cult of Andrew Jackson began with his victory over the English in 1815 at the Battle of New Orleans. Leader of a company of frontier-toughened Tennessee riflemen, he wielded the rising power of the western empire in military and later in political battle. Earl's tight-lipped portrait of the determined hero of New Orleans appeared in several versions throughout Jackson's career in tribute to his reputation as a fighter—of Indians, of English troops, and, later, of Philadelphia bankers and South Carolina "nullifiers." In his assault upon the forces of privilege and of disunion, Jackson became the people's will incarnate, and dramatically transformed the office of the presidency.

ANDREW JACKSON
Ralph Eleaser Whiteside Earl
oil on canvas, circa 1820
76 x 65 cm. (30 x 25½ in.)
Transfer from the National Gallery of Art
Gift of Andrew W. Mellon, 1942 NPG.65.78

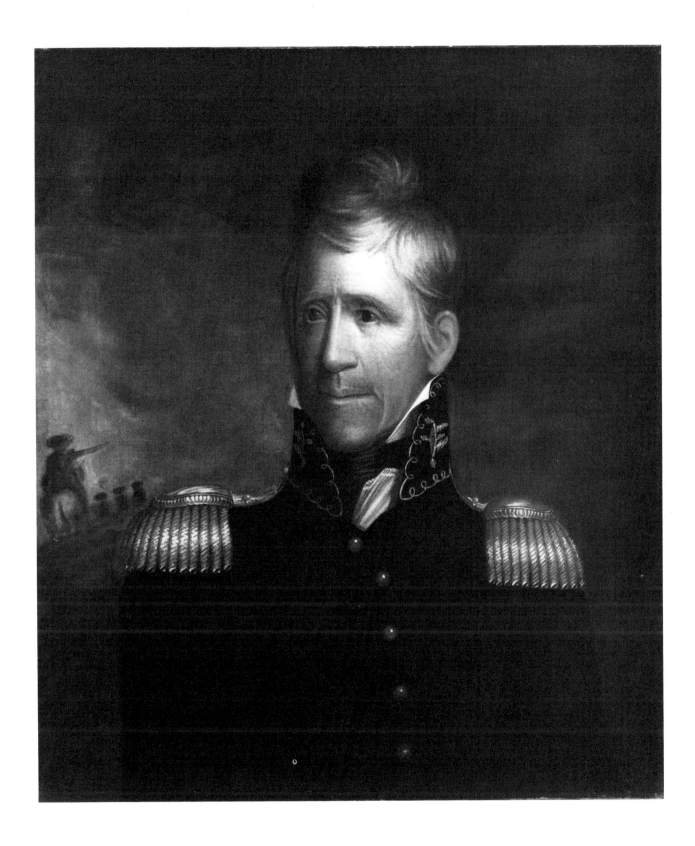

Martin Van Buren

8TH PRESIDENT 1837–1841

There was something entirely too polished about Martin Van Buren for the popular taste. The master strategist of General Jackson's common-touch political campaign was himself too dapper, some said too smooth, to win the trust of the constituency he inherited.

Not for the first time in American politics, appearances deceived. The elegant Van Buren was the son of a New York State tavern-keeper and a determined democrat. But his talents were best exercised in the backrooms and salons of political maneuver, as boss of New York State politics and as confidant to a national hero. When Van Buren became president, in a time of unending economic depression, he suffered a failure of political style no less than of financial policy. In the merciless campaign of 1840, which retired him from office, the voters found it easy to believe their president a heartless aristocrat who dined off silver while the people starved.

Van Buren's self-confidence never left him. After two unsuccessful attempts to regain the presidency, he settled into comfortable retirement. When this daguerreotype was taken, eight years after his final bid for office, he was half forgotten, a fading impression of courtliness in the age of the common man.

MARTIN VAN BUREN
Mathew B. Brady
daguerreotype, circa 1856
14 x 11 cm. (5½ x 4⅝ in.) NPG.76.104

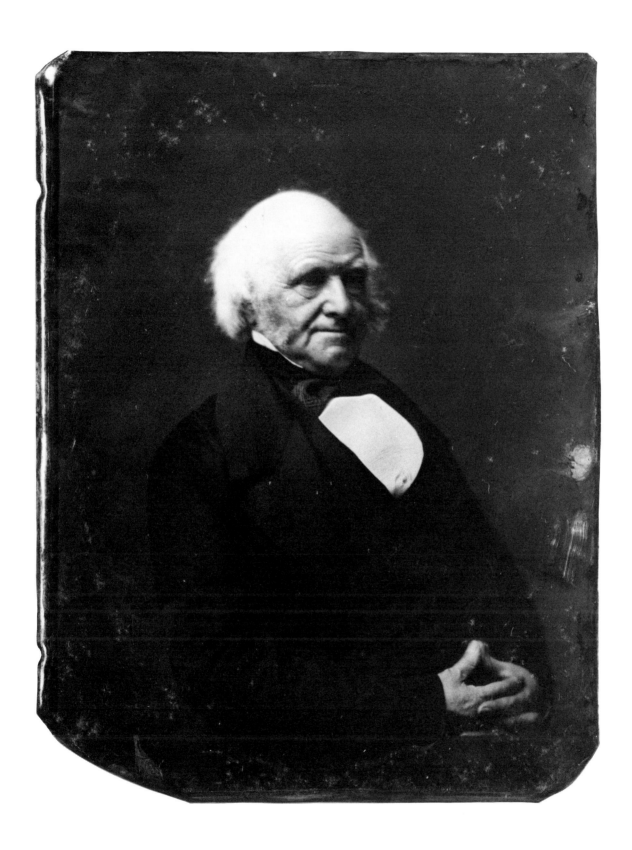

William Henry Harrison

9TH PRESIDENT MARCH–APRIL 1841

William Henry Harrison had already weathered one presidential campaign when Albert Hoit arrived in Connecticut to paint him, in 1840, on the eve of another. Four years before, much had been made of the old warrior's age—his "decrepitude" according to an anti-Whig reporter—but now, in his sixty-eighth year, the voters were encouraged to see old-time virtue mirrored in his face and simple dignity in his erect, military posture.

Harrison was never meant to be more than a figurehead for the loose Whig coalition. The success of the country's most raucous, slogan-ridden campaign to date hinged not on the candidate's political opinions, which he was advised to keep to himself, but on his military glory and common touch. The tide turned in Harrison's favor when his strategists transformed the Virginia-bred gentleman into a man of the people with a taste for hard cider. Badly outmaneuvered, the Jacksonians saw the "aristocratic" Van Buren go down to defeat by the banks of the Tippecanoe River, where Harrison had logged a victory against the Indians more than a quarter-century before.

Whig jubilation was short-lived. A month after the nation's oldest elected president had delivered his inaugural address, coatless and hatless in the cold March climate, he was dead of pneumonia.

WILLIAM HENRY HARRISON
Albert Gallatin Hoit
oil on canvas, 1840
76 x 63.5 cm. (30 x 25 in.) NPG.67.5

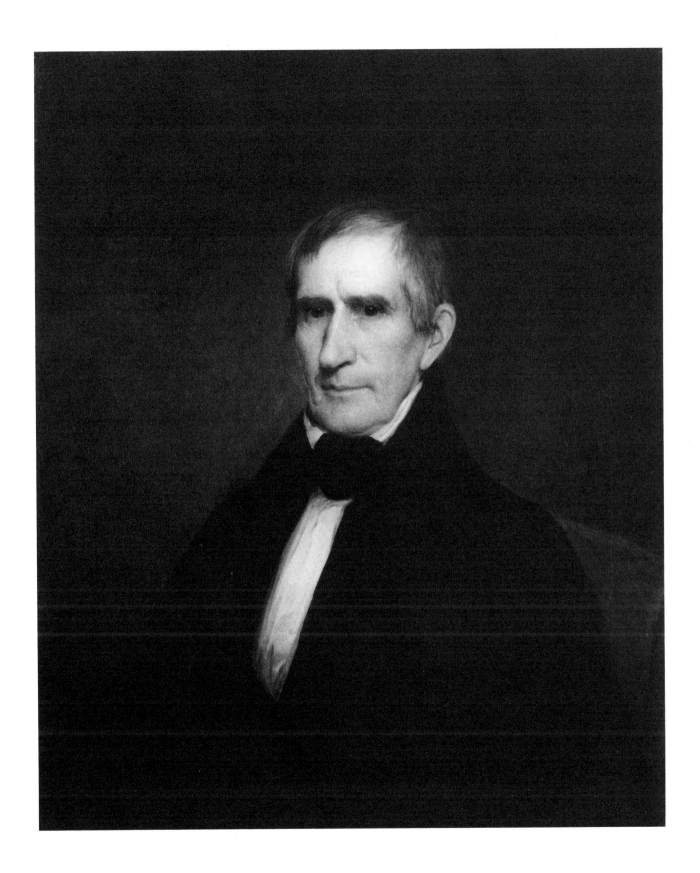

John Tyler

10TH PRESIDENT 1841–1845

John Tyler had the advantage of looking every inch a president—if presidents were meant to exhibit patrician grandeur. But in the aftermath of rough-and-tumble Jacksonianism, they clearly were not. No one had expected the tall Virginia gentleman to become president. As the Southern balance to Harrison's ticket, he succeeded to the office after the old general's sudden death, and promptly put his own stamp on it.

The lofty and resolute Tyler achieved for all vice-presidential successors to the presidency the right to the full authority of the office, but his career was tempestuous. No party man, he alienated his fellow Whigs, his cabinet members, and anyone else who disputed his policy of states' rights. When, in 1842, G.P.A. Healy first painted him, Charles Dickens described Tyler as "at war with everyone."

This tranquil version of presidential grandeur, painted by Healy seventeen years later at the former president's estate, shows an older Tyler with his eye fixed on history. Healy would again paint him in this pose [White House collection], adding a memento of Tyler's one great act of political strategy—the annexation of Texas, accomplished in the dying days of his administration.

JOHN TYLER
George Peter Alexander Healy
oil on canvas, 1859
91.5 x 74 cm. (36⅛ x 29⅛ in.)
Transfer from the National Collection of Fine Arts
Gift of Friends of the National Institute, 1859 NPG.70.23

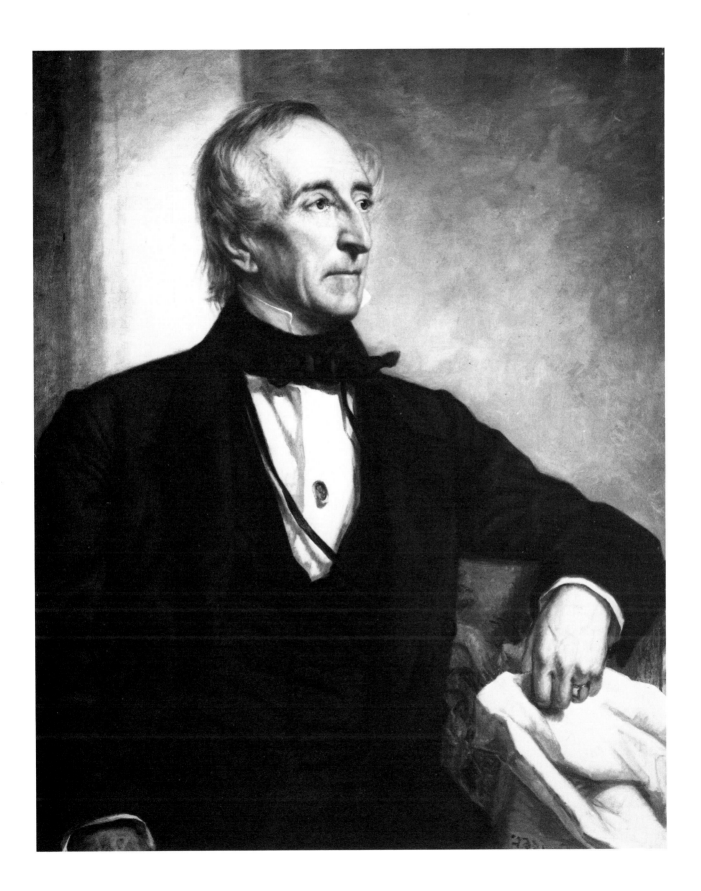

James K. Polk

11th PRESIDENT 1845–1849

When Charles Fenderich set about to produce from life a lithographic "Port Folio of Living American Statesmen" in 1827, he had the foresight or good luck to include the next year a thin, anxious Tennesseean then serving as Speaker of the House of Representatives. Likenesses of James K. Polk were not yet in demand, nor would they be during his subsequent brief term as governor of Tennessee. But when, in the spring of 1844, Samuel Morse's new telegraph flashed the astonishing news from the Democratic convention that Polk had become the first "dark horse" to be nominated by a major party, Fenderich was ready. "Immediately upon the annunciation of the distinguished honor bestowed upon you," he wrote the candidate, "I had numerous applications from all quarters for your lithographic likeness—principally from those who had never seen you."

Once in office, the dark horse became a work horse, and one of the strongest, most effective, and most humorless of the presidents. Unable to delegate responsibility, fierce in his attention to detail, tyrannical to his cabinet, Polk embarked upon a determined program to implement his four key goals: "One, a reduction of the tariff; another the reestablishment of an independent treasury; a third, the settlement of the Oregon boundary question; and, lastly, the acquisition of California." To achieve them, and achieve them he did, Polk triumphantly waged countless political battles, an extended war of nerves with Great Britain over the Northwest's 49th parallel, and a punishing, controversial war with Mexico.

Never popular, Polk willingly left office after one term, satisfied but exhausted. "He was the most laborious man I have ever known," wrote his eventual successor, James Buchanan, "and in a brief period of four years had assumed the appearance of an old man." Three months later, Polk was dead.

JAMES K. POLK
Charles Fenderich
lithograph, 1838
30.3 x 26.7 cm. (11 15/16 x 10½ in.) NPG.77.145

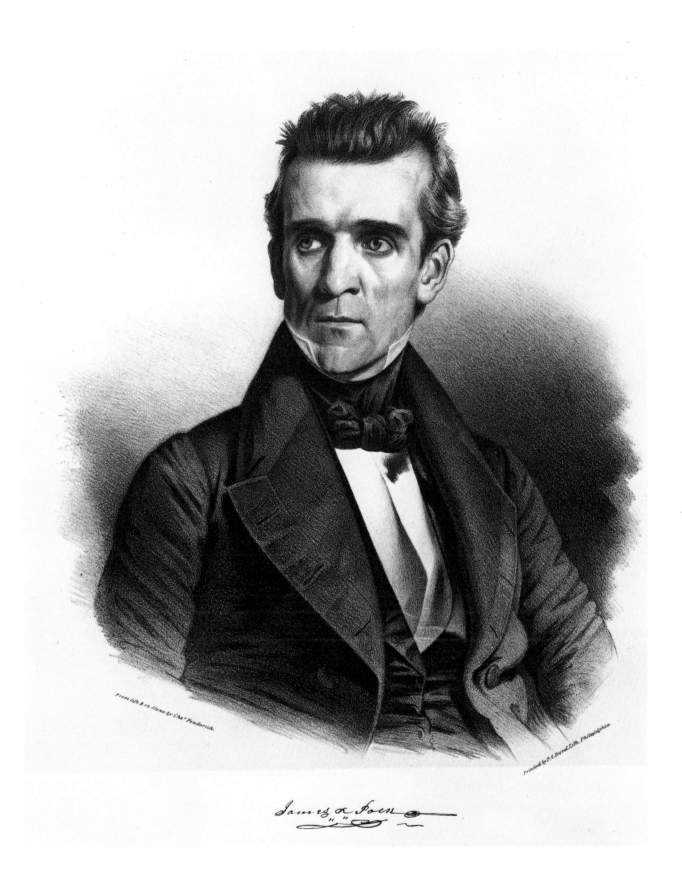

From lith'd on Stone by Cha: Fenderich.

Printed by P.S.Duval Lith, Philadelphia

James K Polk

Zachary Taylor

12TH PRESIDENT 1849–1850

Posing for the presidency, Zachary Taylor presented a deceptively sedate and groomed figure to the nation in this election-year portrait by James Lambdin. "Old Rough and Ready," as his soldiers knew him, usually dressed "entirely for comfort," wrote Lt. Ulysses S. Grant—his uniform an accidental mating of military and civilian clothes.

The transformation of gruff old soldier into presidential candidate took place on the battlefields of the Mexican War. To the consternation of President Polk, General Taylor seized the imagination of the American public with his victory, at Buena Vista, over the superior forces of Santa Anna. Awarded the Whig nomination in 1848, Taylor—who had never voted in his life—became the archetypal military hero as presidential nominee: a man above politics.

But in his brief fifteen months of authority before dying in office, Taylor was pulled into the maelstrom of antebellum politics. The calm which had made him famous as a general, interpreted here as solid self-confidence, never left him. A slaveholder, he nevertheless declared himself opposed to the extension of slavery, and he threatened to hang for treason anyone who interfered with the admission of California as a free state. Had Taylor lived, he might not have quieted the secessionists, but the resolution of the issue of slavery would not have been postponed.

ZACHARY TAYLOR

Attributed to James Reid Lambdin
oil on canvas, 1848
77 x 63 cm. (30¼ x 24¾ in.)
Gift of Barry Bingham, Sr. NPG.76.7

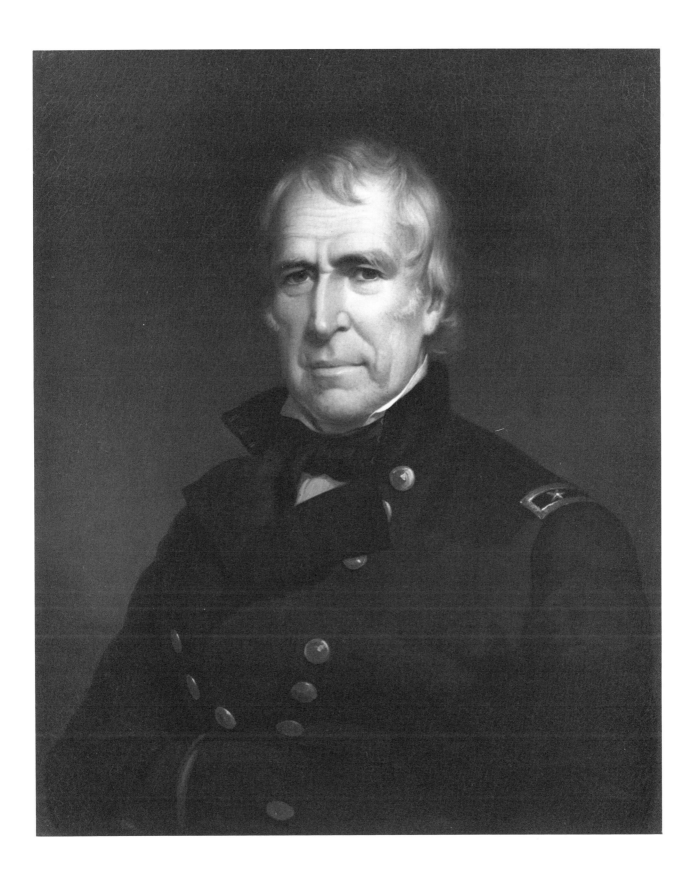

Millard Fillmore

13TH PRESIDENT 1850–1853

Not an emotional man himself, Millard Fillmore never fully understood the regional passions which gathered around the issue of slavery. An institution which the New England conscience found outrageous and Southern honor pronounced sacred seemed to the moderate Whig from upstate New York distasteful certainly, but secondary to the preservation of union. When Zachary Taylor and he, the vice-presidential candidate, were swept into office in 1848, Fillmore complacently assumed that their victory had put "an end to all ideas of disunion."

The vice president's incantations of union became presidential policy on July 9, 1850, when Fillmore succeeded the stricken Zachary Taylor in office. Two months later, he signed into law the Compromise of 1850, and with it his own political death warrant. Unforgiven by the Northern Whigs for his willing enforcement of the Fugitive Slave Law, which required the return of slaves to their owners, Fillmore was denied his party's renomination two years later.

The former president persisted doggedly in his avoidance of the slavery issue. In 1856 he accepted the nomination of the American "Know-Nothing" party in an attempt to divert attention from the regional politics of the Democratic and the newly formed Republican parties. Rejected by the electorate overwhelmingly, Fillmore began his steep descent into obscurity.

MILLARD FILLMORE
Unidentified artist
oil on canvas, date unknown
76 x 63.5 cm. (30 x 25 in.) NPG.78.50

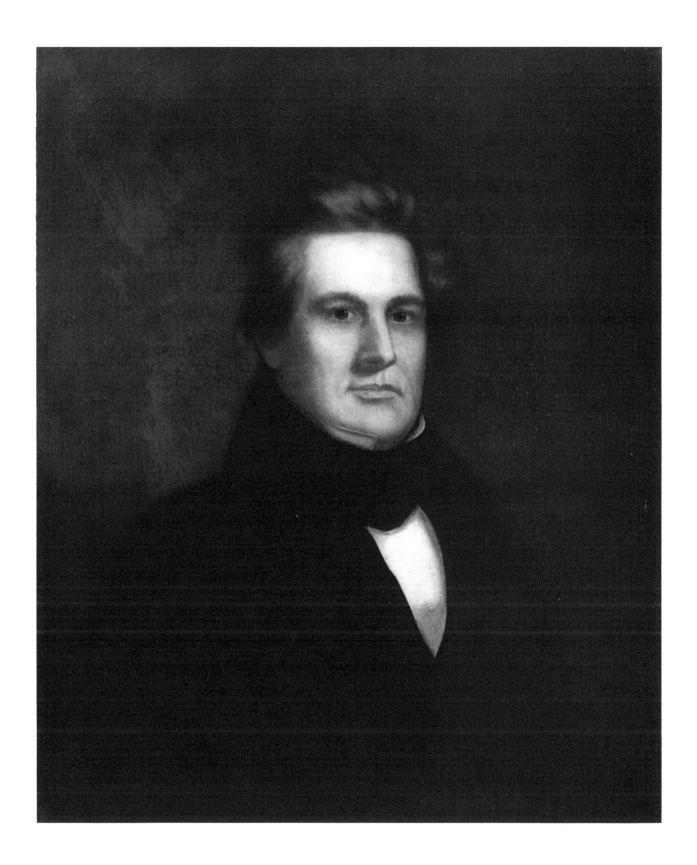

Franklin Pierce

14TH PRESIDENT 1853–1857

When the Democratic party nominated Franklin Pierce for the presidency on the forty-ninth ballot, the most that could be said for him was that he was a "first rate good fellow." In peaceful times, that might have been enough to have guaranteed a modest success in the White House. But the 1850s were not peaceful times.

Pierce had a deceptive look of self-confidence. His handsome face and great personal magnetism overlaid a weak nature that courted popularity. When G.P.A. Healy painted his portrait in the first year of his administration, the young president had already embarked on a policy of vacillation. Eager to please everyone, he displeased all in his selection of a cabinet of squabbling pro- and anti-slavery factions. The national squabbling turned murderous when Pierce lent his support to the Kansas–Nebraska Act, leaving to the bitterly divided inhabitants of Kansas the right to decide the issue of slavery in their territory.

The amiable Pierce ended up among the most unpopular of presidents. Denied his party's renomination, he retired to resentful political exile in his native New Hampshire.

FRANKLIN PIERCE
George Peter Alexander Healy
oil on canvas, 1853
76 x 64 cm. (30 x 25¼ in.)
Transfer from the National Gallery of Art
Gift of Andrew W. Mellon, 1942 NPG.65.49

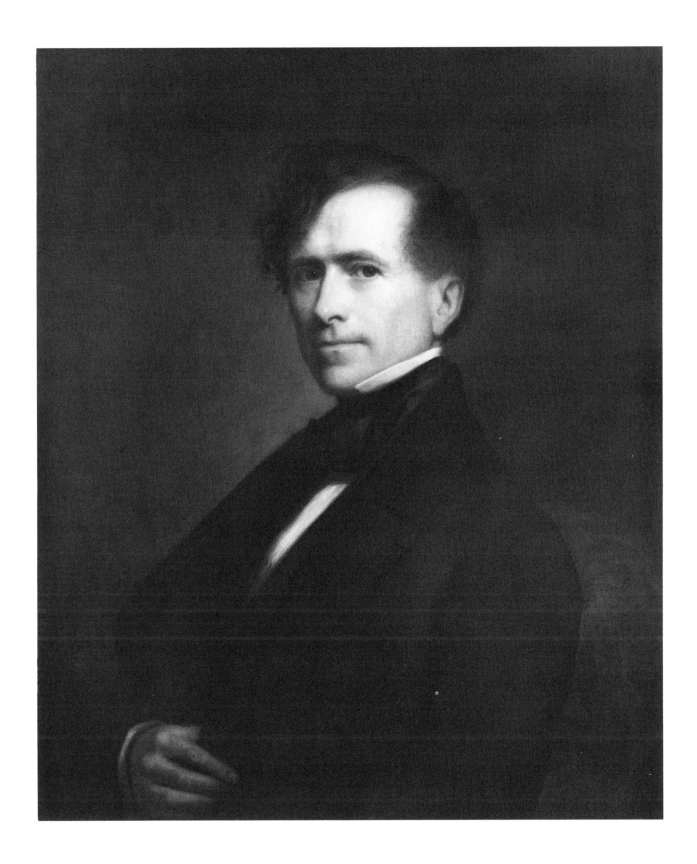

James Buchanan

15th PRESIDENT 1857–1861

James Buchanan, his figure erect, his hand resting confidently on the documents of state, struck an attitude of authority for his portrait by G.P.A. Healy. But hostile contemporaries saw in the likeness only "the sad, placid visage of poor Mr. Buchanan . . . with the lack-lustre eye, and the infirm weak old mouth"—a president presiding over a dissolving nation.

Buchanan's reputation for weakness has persisted to modern times. A strong president, we sense, might have saved the Union. But it was not strength so much as flexibility and perspective that Buchanan lacked. Believing that the Constitution had settled the issue of slavery, he was insensitive to the moral intensity of the North—although himself a Pennsylvanian. Buchanan's support of the Dred Scott Decision and a proslavery constitution for a bleeding Kansas had alienated even the moderate Northerners in his own Democratic party by the time Healy painted him in 1859. His head tilted forward to compensate for a cast in one eye, Buchanan seemed an attentive listener, but in the end he heard nothing—until the firing of the guns on Fort Sumter.

JAMES BUCHANAN
George Peter Alexander Healy
oil on canvas, 1859
157.5 x 119.5 cm. (62 x 47 in.)
Transfer from the National Gallery of Art
Gift of Andrew W. Mellon, 1942 NPG.65.48

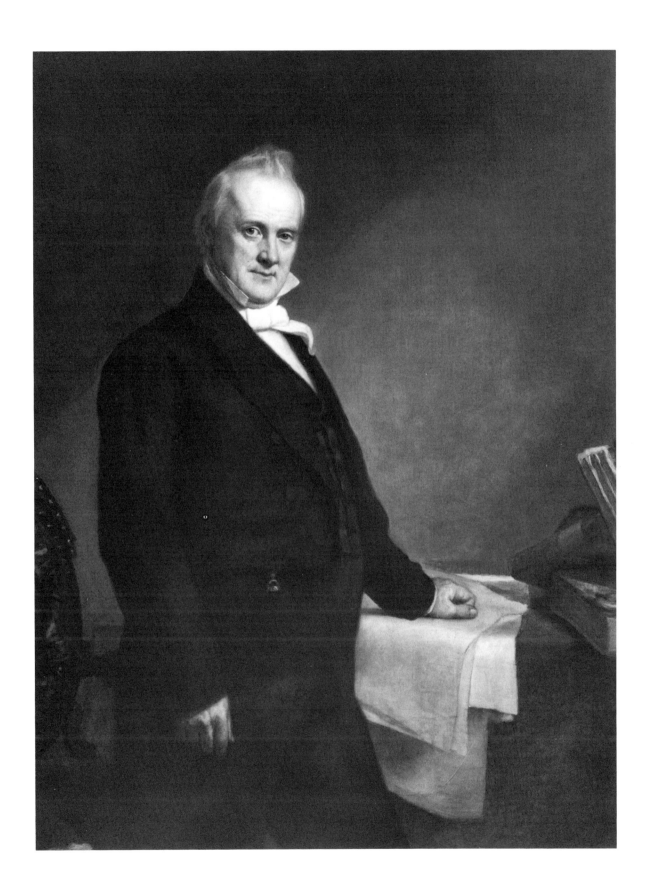

Abraham Lincoln

16TH PRESIDENT 1861–1865

"Now he belongs to the ages," Secretary of War Edwin M. Stanton's epitaph at Lincoln's deathbed, was taken to heart by generations of portraitists. Among them, G.P.A. Healy produced the most enduring painted image of the martyred president. Poised here between life and myth, not quite flesh and blood and yet not entirely lost to dreamy idealization, Healy's Lincoln sits in contemplation of the tragedy of civil war.

Healy was able to base his portrait on life sketches, which he had made in 1864. Lincoln sits here as his contemporaries remembered him listening to them, the lanky frame supported but not contained by his chair, the long legs heaped one across the other, the body bent in concentration. When Healy first painted Lincoln in this pose as one of a group of "Peacemakers" [White House collection] which also included Generals Grant and Sherman and Admiral David Porter, the figure of the president already seemed withdrawn from active participation in everyday affairs. In this later version, one of four the artist painted in the 1880s, Lincoln sits finally alone, no longer war strategist, pragmatic politician, or backwoods storyteller, but a melancholy symbol of the national ordeal of union.

ABRAHAM LINCOLN
George Peter Alexander Healy
oil on canvas, 1887
188 x 137 cm. (74 x 54 in.)
Transfer from the National Gallery of Art
Gift of Andrew W. Mellon, 1942 NPG.65.50

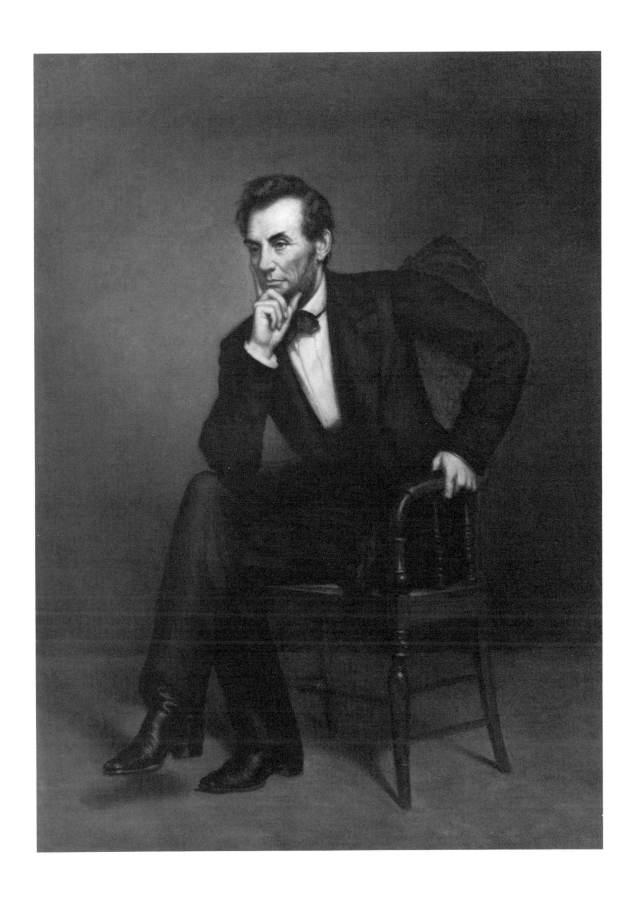

Andrew Johnson

17TH PRESIDENT 1865–1869

Andrew Johnson was a man of definite opinions. Humorless and belligerent, he had reached "the summit of my ambition" about the time this photograph was taken, when he entered the United States Senate as a battle-scarred veteran of the Tennessee political wars. An enemy of the patrician class and its secessionist cause, Johnson balked when the Southern bloc abandoned the Senate three years later. "I am in the Union," he said, "and intend to stay in it."

Johnson's uniqueness as a Southern loyalist thrust him into the vice-presidency in 1864, but made him an unlikely Reconstruction president in the aftermath of Lincoln's assassination. Indignant at Northern reluctance to mend the shattered Union and insensitive to the rights of the freedmen, Johnson infuriated even moderate Republicans with his "habit of denunciatory declaration" and relentless use of the veto. When congressional antagonism boiled into political vengeance, the president stood his ground, surviving by one vote the Radicals' attempt, in 1868, to remove him from office.

Unbowed but without influence, Johnson served out his term and returned to Tennessee. Six years later, and within four months of his death, he was back in the Senate, enjoying at last—in the calmer political climate—a final sweet moment of reconciliation.

ANDREW JOHNSON
Attributed to W.A. Wonderly
salt-print photograph, circa 1857
20.8 x 15.7 cm. (8³⁄₁₆ x 6³⁄₁₆ in.) NPG.77.58

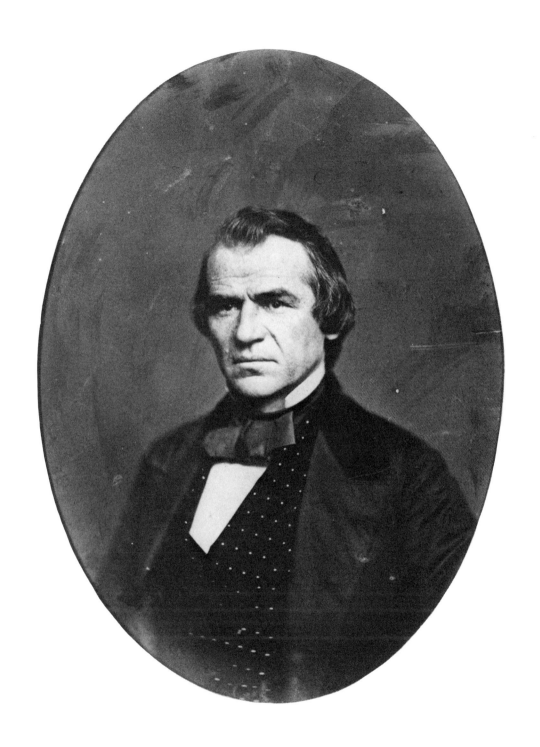

Ulysses S. Grant

18TH PRESIDENT 1869–1877

As the Union's final campaign was gathering momentum in Virginia, the Norwegian artist Ole Peter Hansen Balling met Ulysses S. Grant and was struck by the general's unpretentious look—his "big slouch hat," his ever-present cigar, his direct but quiet spirit. The following year, in 1865, Balling painted Grant with his generals [National Portrait Gallery collection] in full military display. But he reserved for this commemorative portrait of Grant at the siege of Vicksburg, painted also in 1865, his reading of the subdued inner man, the very opposite of the preening victor. "The General looks careworn and weary," wrote Julia Grant of the portrait, "and the picture I think really portrays him as he looked at this time. . . . The earnest look he wears reminds me most forcibly of that sad summer."

Grant's virtues as military leader—his earnestness, tenacity, and trust in subordinates —ill suited his presidency. A man of direct action who was unused to political subtleties, he found himself, three years after the war, in an uncongenial office, dependent on the counsel of self-serving advisers and allies. Surrounded by excess, the hero was never himself tempted, but his name became associated with a shallow age.

Long after his retirement from a second term even more scandal-ridden than the first, Grant touched again the elements of his greatness. The *Memoirs*, written during his last, cancer-wracked months, made vivid once more the austere and determined commanding general about whom Lincoln had said, "I can't spare this man. He fights!"

ULYSSES S. GRANT
Ole Peter Hansen Balling
oil on canvas, 1865
101.5 x 76 cm. (40 x 30 in.) NPG.67.34

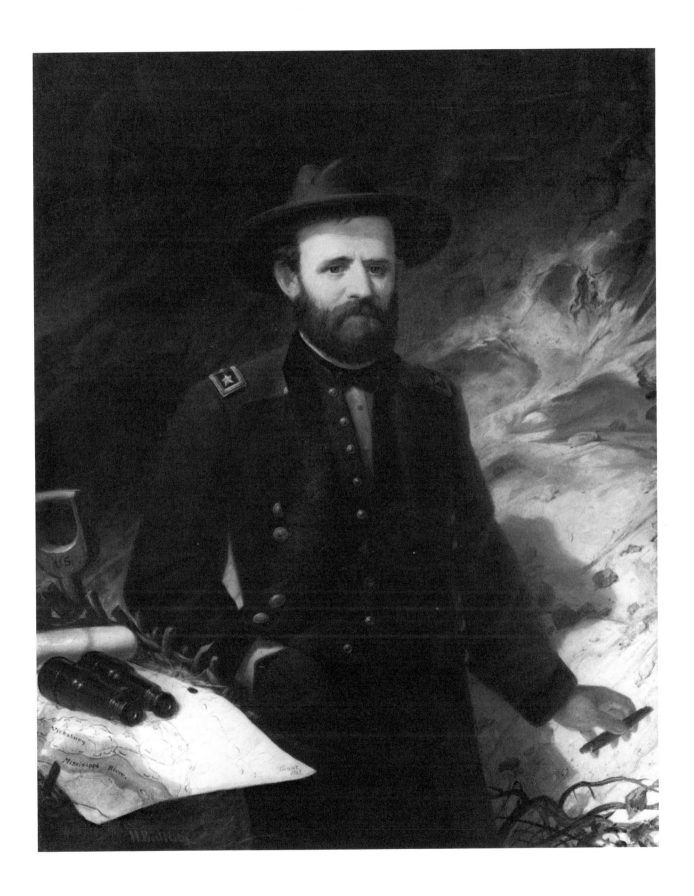

Rutherford B. Hayes

19TH PRESIDENT 1877–1881

Olin Warner had every reason to believe that his portrait of Rutherford B. Hayes would be a popular success. Completed in the fall of 1876 after the three-time governor of Ohio had been nominated for the presidency, the half-life-size bust captured the rectitude, the worried earnestness, and the full-bearded dignity of the man commissioned to cleanse the reputation of the Republican party.

Hayes achieved the presidency, but there was no great demand for copies of his likeness. In the most contested presidential election in American history, complicated by competing electoral slates from three Southern states and relentless wheeling and dealing, a divided congressional commission awarded each of these states to Hayes 8–7 along strict party lines. President by one tarnished electoral vote, and loser to Tilden in the popular count, Hayes entered office to the catcalls of outraged Democrats.

Yet Hayes surprised his detractors. The first postwar Republican leader to preach reconciliation with the defeated South, he removed all federal troops and withdrew support from the carpetbag governments—a gesture widely hailed as progressive. To a nation as tired of political corruption as of regional division, he proposed dismantling the spoils system. But, above all, the man whose colleagues had moved heaven and earth to put in office relinquished all interest in a second term and quietly retired to his Ohio estate.

RUTHERFORD B. HAYES
Olin Levi Warner
plaster cast, 1876
27.5 cm. height (10⅞ in.)
Transfer from the National Collection of Fine Arts
Gift of Rosalie Warner Jones, the sculptor's daughter, 1974 NPG.76.27

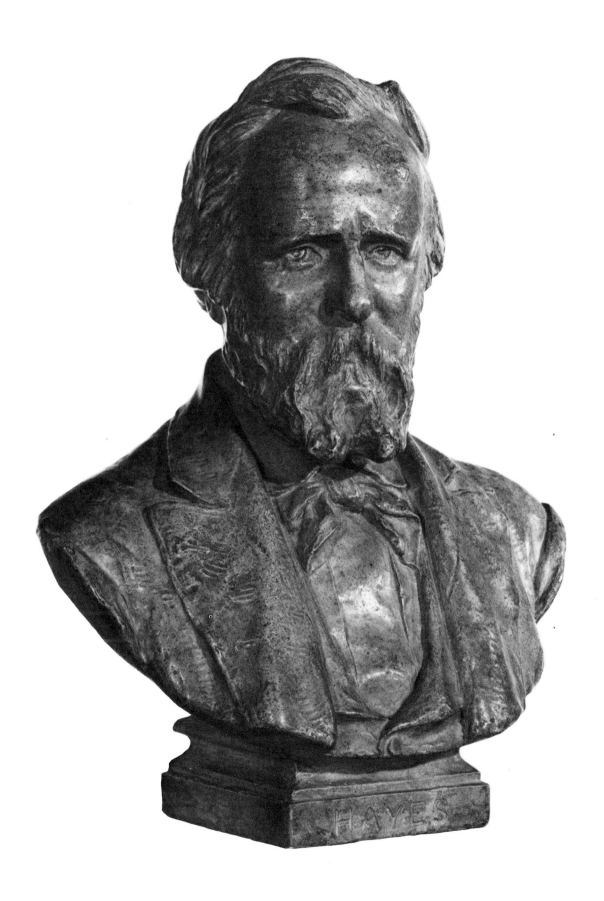

James A. Garfield

20TH PRESIDENT MARCH–SEPTEMBER 1881

Balling's cloudy, noncommittal portrait of James Garfield has an odd validity. Presumably based on a photograph taken in 1880, the year of Garfield's nomination, it portrays the modulated, expressionless congressman-turned-president as he presented himself to the world. In an era of strong emotions, greed, and antagonistic ideals, Garfield trod the middle course of party loyalty and legislative strategy—sympathetic to reform but not an active reformer, against corruption but willing to work with the corrupt.

Chosen by the Republicans to break the deadlock between reformers and supporters of the spoils system, Garfield rode the advantages of his log-cabin birth, military prowess, and success as a nine-term Ohio congressman to the White House. But he remained there only four months. The second president to suffer assassination, he died, after lingering three months, at the hands of a disappointed office seeker.

Garfield's death was an outrage, but not a martyrdom. Unlike Lincoln, who had died as the symbol of union, Garfield was the tragic victim of an act that had meaning only in the erratic mind of his assassin, Charles Guiteau.

JAMES A. GARFIELD
Ole Peter Hansen Balling
oil on canvas, 1881
61 x 51 cm. (24 x 20 in.)
Transfer from the National Collection of Fine Arts
Gift of the International Business Machines Corporation to
the Smithsonian Institution, 1962 NPG.65.25

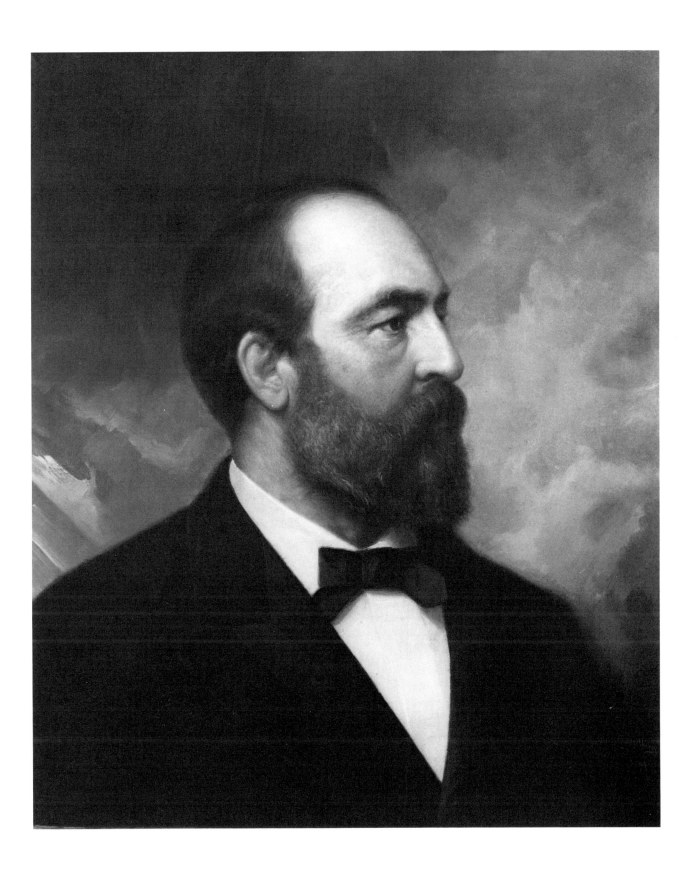

Chester A. Arthur

21st PRESIDENT 1881–1885

If Chester Arthur looks somewhat bewildered in this portrait by Balling, done in the year of his sudden elevation to the presidency, he was no more surprised than the nation who inherited him. "Mr. Arthur," wrote the New York *Sun* after Garfield's death, "is not a man who would have entered anybody's mind as a direct candidate for the office." Even his political friends, who valued his services as patronage boss of the New York customs office, had not expected Arthur to emerge from the back rooms. His enemies, Republican reformers of the spoils system chief among them, saw no less than "a national calamity" in the inauguration of New York's "gentleman boss."

Arthur has become a figure of awesome obscurity in the annals of the presidency, but he has, at least, been spared the notoriety expected of him. Colorless in leadership if elegant in his personal style, he administered the nation with remarkable probity, amounting, thought some of his former colleagues, to a betrayal of old friends. When he promoted the first civil-service legislation, the surprise was complete. Deprived of his former political base and uninspiring to those who respected his reform efforts, Arthur retired after his first term into the shadows of American history.

CHESTER A. ARTHUR

Ole Peter Hansen Balling
oil on canvas, 1881
61.5 x 51 cm. (24⅛ x 20⅛ in.)
Gift of Mrs. Harry Newton Blue NPG.67.62

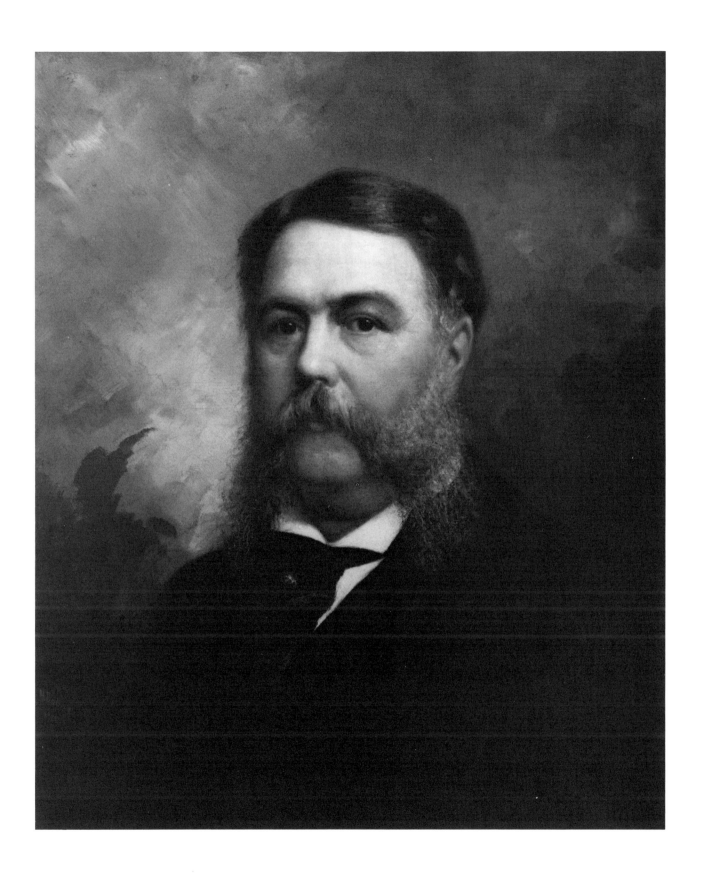

Grover Cleveland

22D PRESIDENT 1885–1889
24TH PRESIDENT 1893–1897

After the unnatural quiet of the Arthur years, the American people were ready for an active president. What they got was a dynamo. Grover Cleveland, whose self-described "homely, burly face" Eastman Johnson painted as the governor stood fidgeting on the brink of his nomination, was a man of fierce energy harnessed to an iron conscience. Reform Democratic mayor of Buffalo and "veto governor" of New York, he was "loved," cheered one delegate at his nominating convention, "for the enemies he has made."

Cleveland left the White House in 1889 far less loved. He had bruised too many sensibilities with his rough honesty, and had taken unpopular positions in favor of the gold standard and against the protective tariff. Four years later, as the country foundered in economic crisis, Cleveland was again elected president, but neither he nor his opponents had mellowed. Heir to a depression which worsened during his administration, the president struggled with the cheap-money advocates and earned the hatred of labor by suppressing the Pullman strike. His energy never faltered, but by the end, when his principal rival, William Jennings Bryan, swept the Democratic nomination, his spirit lagged. A man of force not of strategy, Cleveland had matched his age in drive, but he had not been able to master it.

GROVER CLEVELAND
Eastman Johnson
oil on artist board, 1884
58 x 47.5 cm. (22¾ x 18¾ in.)
Gift of Francis G. Cleveland NPG.71.58

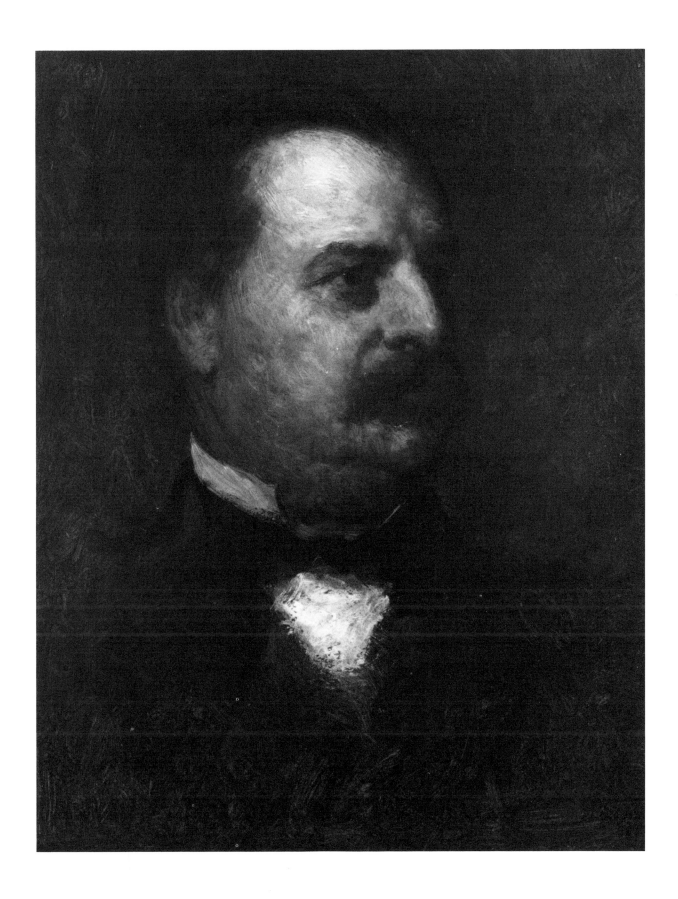

Benjamin Harrison

23D PRESIDENT 1889–1893

Benjamin Harrison was not a man to fire up voters, political colleagues, or portraitists. The gray respectability which he wore tightly, like a pair of kid gloves, enhanced his position as a prosperous lawyer in Indianapolis but made him an off-putting political figure, so unlike his grandfather, "Old Tippecanoe." The irony of his origins was not lost on the voters. In his first bid for a major office, "Kid Gloves" Harrison lost the governorship of Indiana to an earthy man nicknamed "Blue Jeans" Williams.

Harrison survived in politics through two strokes of luck: his appointment to the Senate by Indiana's Republican legislature in 1880, and his selection for the Republican presidential nomination as James G. Blaine's candidate in 1886. Lacking his own constituency, Harrison owed his victory to the party managers, who dictated his cabinet but never felt comfortable in the presence of the "iceberg." Although Harrison's administration registered some important successes, notably Secretary of State Blaine's friendly overtures to Latin America and the construction of a modern navy, it became identified with political bickering, excessive spending, and overt favoritism toward big business. The president, somewhat to his relief, lost his bid for a second term and resumed the pose of distant dignity which Eastman Johnson captured in this sketch for the official White House portrait.

BENJAMIN HARRISON
Eastman Johnson
charcoal and chalk on paper, circa 1889
45.7 x 30.5 cm. (18 x 12 in.) NPG.68.4

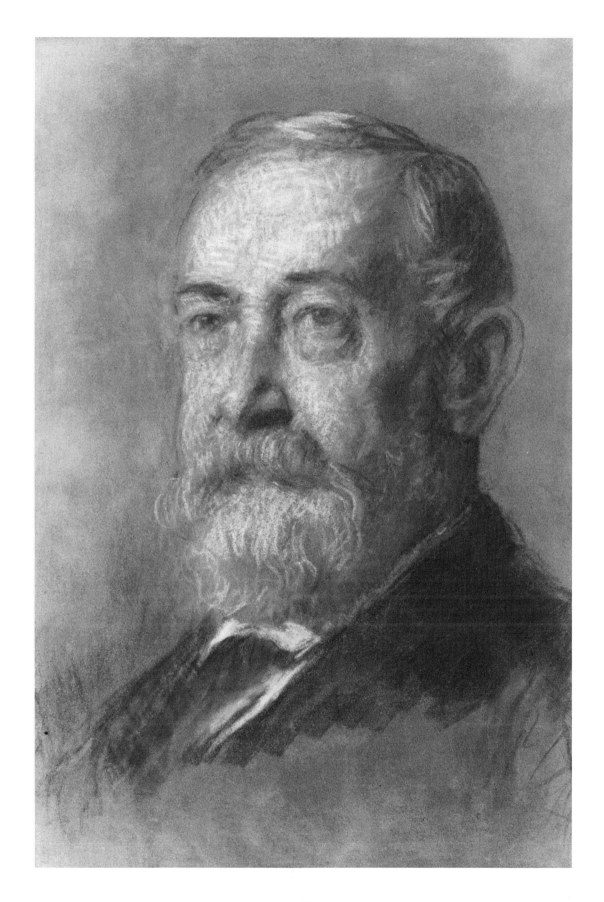

William McKinley

25TH PRESIDENT 1897–1901

William McKinley did not expect to be the first president to preside over an overseas empire. A cautious man who put his trust in sound money and high tariffs, he conducted a placid campaign from his front porch in Ohio and promised the nation no remarkable adventures. But the adventures did come and with them the awkward novelty of empire.

On the morning of February 16, 1898, as the Swiss artist August Benziger was painting his portrait, McKinley received word that the U.S.S. *Maine* had exploded in Havana harbor. The president resisted the implication that the Spanish were responsible, but in the mounting atmosphere of crisis, which Benziger witnessed and recorded in McKinley's pensive look, he was forced by the jingoists to "Remember the *Maine*," and the nation went to war. In ten weeks it was over—with Cuba independent, Puerto Rico and Guam absorbed into the American commonwealth, and soon after, the resistant Philippines put under American control. A now-exultant McKinley pronounced it the work of Providence.

Although the anti-imperialists questioned the propriety of republican empire, McKinley was rewarded with a second term. He died at the hand of an anarchist six months after his inauguration.

WILLIAM McKINLEY

August Benziger
oil on canvas, 1897
149 x 99 cm. (58¾ x 39 in.)
Gift of Miss Marieli Benziger, the artist's daughter NPG.69.34

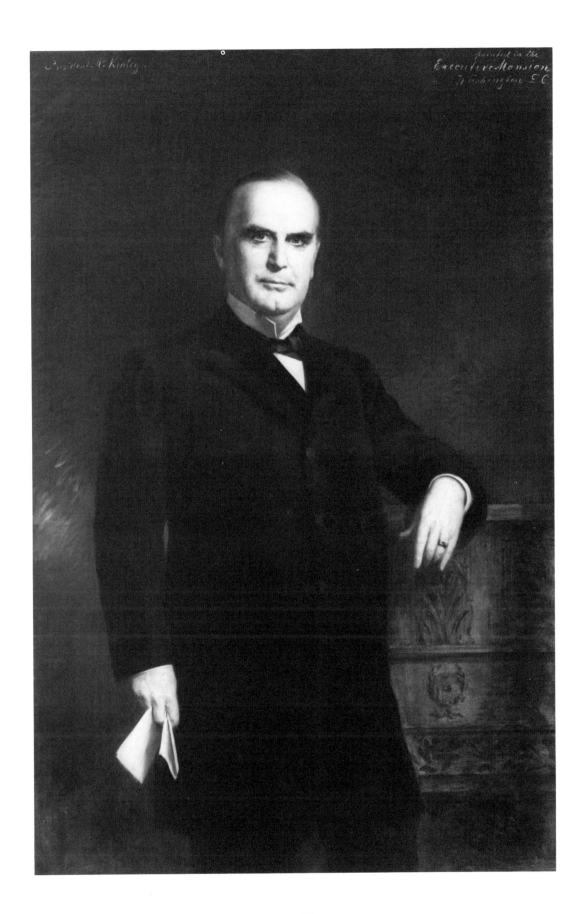

Theodore Roosevelt

26TH PRESIDENT 1901–1909

No one craved the presidency more than Theodore Roosevelt, or used its authority so joyously while in office, or chafed so miserably in retirement. Peering out through his pince-nez, fingering the gold fob he customarily wore, Roosevelt might have been dismissed as a gentleman dabbler in politics but for the raw force of his nature, and the intensity of his commitment to presidential power as the foundation of national order.

Resolved, as he put it, "not to content himself with the negative merit of keeping his talents undamaged in a napkin," TR rode roughly through a series of adventures on his way to the presidency: as a rancher in the Dakota Badlands, as police commissioner of his native New York City, as jingoist and cavalry hero of the Spanish–American War, and as reform governor of New York. Caught momentarily in the sterile dignity of the vice-presidency during McKinley's second term, Roosevelt found himself in control of the White House and of his highest ambitions in 1901. As president for a new century, he shattered his predecessors' tradition of executive restraint by creating a strong national authority to equal and balance the domineering wealth of industry and the rising power of labor. The energy he could not absorb in domestic politics he expended in saber-rattling in Latin America—which produced the Panama Canal, and a lasting legacy of bitterness—and in exercising diplomacy to settle the Russo–Japanese War, which won him the Nobel Peace Prize.

Teddy Roosevelt was a vitalizer, an inspirer of movement and optimism in others. "Get action," he trumpeted, "do things, be sane." Taking him to heart as a rousing symbol for youth, the Jacob Riis Settlement House in New York City commissioned Sally Farnham in 1905 to execute this bronze plaque to fix to the wall of their gymnasium —an unexpected tribute to a president, but for Theodore Roosevelt an entirely appropriate one.

THEODORE ROOSEVELT
Sally James Farnham
bronze relief, 1906
52.5 x 52.5 cm. (20⅝ x 20⅝ in.) NPG.74.16

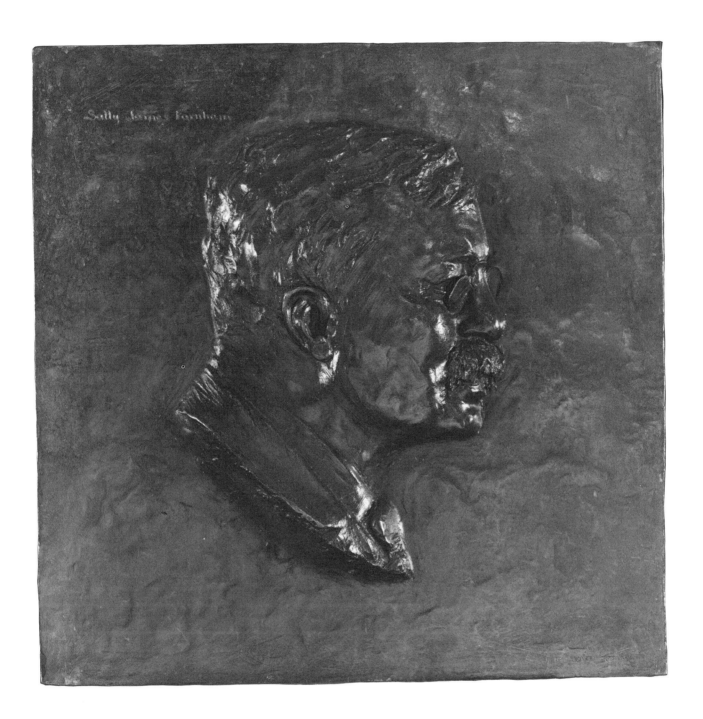

Sally James Farnham

William Howard Taft

27th PRESIDENT 1909–1913

For all his three hundred pounds, William Howard Taft, looming here in 1909 at the beginning of his term in office, cast a very small presidential shadow. Hand-picked by Teddy Roosevelt to succeed him in the new tradition of the energetic, combative presidency, Taft proved unable to capture the imagination of his party and his public. "I am going to be honest with myself," he wrote, "I cannot be spectacular."

Taft's failings were all of style and political instinct. In action he proved a well-meaning, judicious, and effective executive. Veteran of an enlightened administration as America's first high commissioner to the Philippines and of some years as Teddy Roosevelt's principal troubleshooter, he conscientiously developed programs as a presidential "trust-buster" and conservationist which exceeded Roosevelt's own achievements. But TR had accustomed the American public to a presidency which inspired more than it administered. Taft's self-described "consistent, steady, quiet course" seemed to his predecessor more than a failing, a repudiation of leadership. The president's predicament, compounded by the innocence of his relations with political adversaries, led inexorably to a split within the Republican ranks and the challenge, in 1912, of Roosevelt's Bull Moose party. Taft received, in the end, only eight electoral votes.

However, like John Quincy Adams before him, Taft achieved fulfillment after his presidency. Appointed in 1921 Chief Justice of the United States by Warren Harding, he embarked upon a career entirely in keeping with his conciliatory, genial temperament. The self-confessed "fish out of water" in the presidency was finally, as he had guessed years earlier, "entirely at home."

WILLIAM HOWARD TAFT
Robert Lee MacCameron
oil on canvas, 1909
98 x 81 cm. (39½ x 31⅞ in.)
Gift of Robert F. MacCameron and Marguerite MacCameron,
the artist's son and daughter NPG.65.10

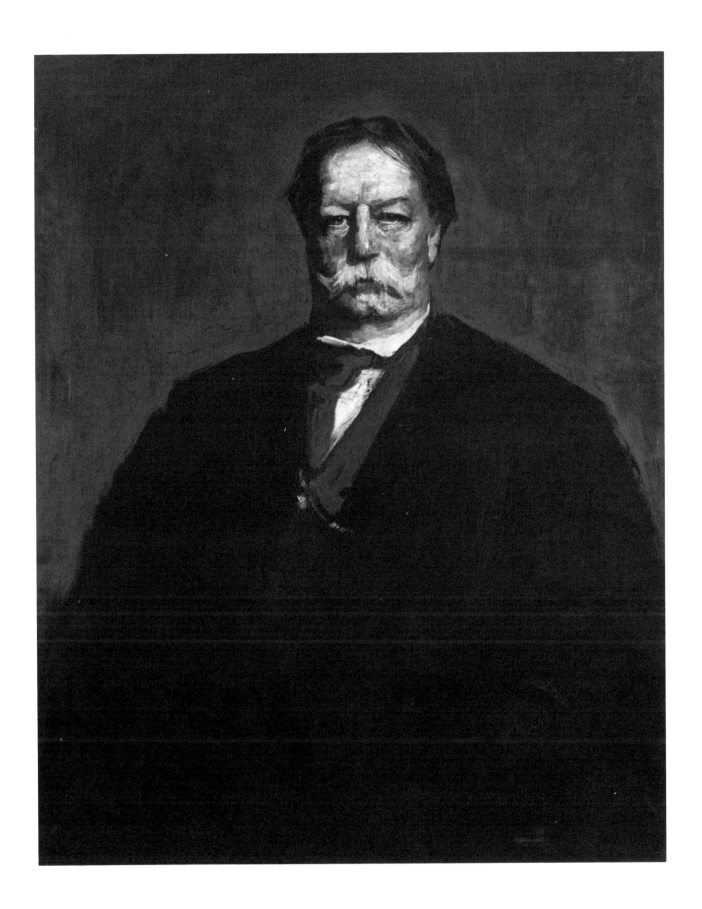

Woodrow Wilson

28TH PRESIDENT 1913–1921

Woodrow Wilson was portrayed in this, one of the most disheartened of presidential portraits, in early 1921, soon after his slow recovery from a debilitating stroke and after the final defeat of his program for American participation in the League of Nations. Commissioned well over a year before by a committee of well-wishers, the portrait was intended to describe the president at his moment of triumph: as leader of a victorious nation and prophet of a new postwar world order. It became, instead, the haunted image of a defeated visionary.

Wilson's debacle—the principal setback in an otherwise fortunate life as Princeton professor and president, New Jersey governor, and twice-elected president of the United States—may have been unavoidable, given the American tradition of isolationism. But the president contributed to his own defeat. In the loftiness of his appeals, he bred inevitable disillusionment and cynicism; in the self-righteousness of his character he invited suspicion and hostility. Convinced that he alone was custodian of his "sacred mission," Wilson, who had conceded much at Versailles, would concede nothing in his rhetoric or in his relationship with a hostile Republican Congress. At a time when Americans were uneasy about the rush to internationalism, the president proved unable to mollify their fears. But if Wilson stumbled as a politician, his was the greater vision of America's new realities and responsibilities: "We are participants, whether we would or not in the life of the world. . . . What affects mankind is inevitably our affair as well."

WOODROW WILSON

Edmund Charles Tarbell
oil on canvas, 1921
117 x 92 cm. (46 x 36¼ in.)
Transfer from the National Collection of Fine Arts
Gift of the City of New York through the National Art Committee, 1923 NPG.65.42

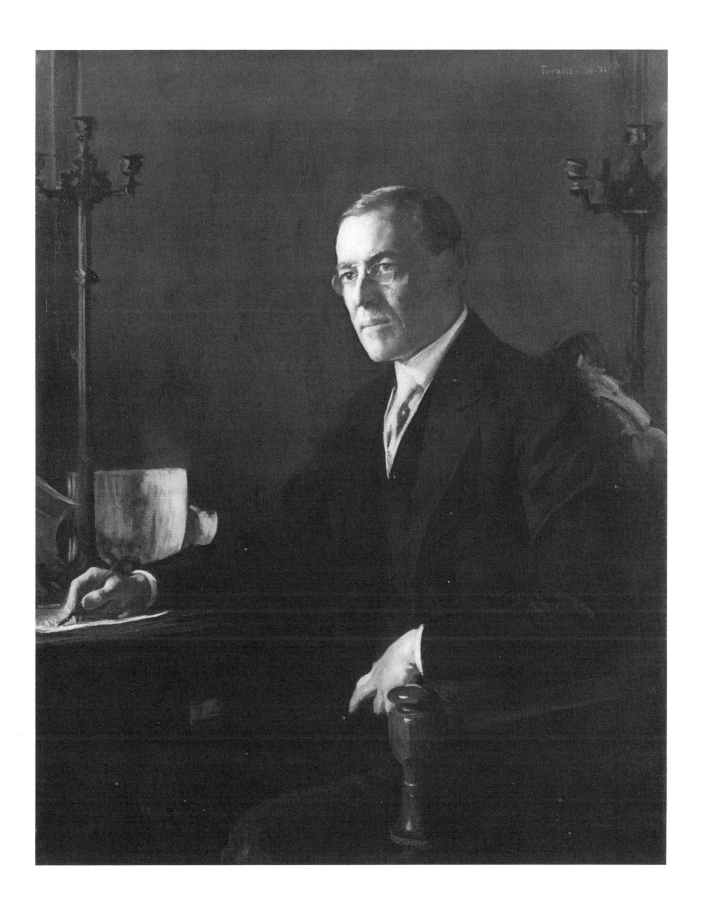

63

Warren G. Harding

29TH PRESIDENT 1921-1923

After the strain of a World War and the moral intensity of the Wilson presidency, America relaxed with Warren Harding. The temperament which made him an active joiner of the Masons and the Elks, an affable poker player, and an all-around "regular fellow" suited perfectly the national yearning for what Harding called "normalcy." Harding could look like a president when he wanted to, all authoritative respectability as in the tribute-portrait painted of him by Margaret Williams for the English-Speaking Union of London (of which this is the artist's own version), but he never lost the back-room quality of a small-town editor from Marion, Ohio, happiest when dealing cards and swapping stories.

The Harding cabinet was an odd mixture of such statesmen as Secretary of State Charles Evans Hughes, Secretary of Commerce Herbert Hoover, and Secretary of the Treasury Andrew Mellon, and a number of political cronies like Secretary of the Interior Albert B. Fall, and Attorney General Henry M. Daugherty. Although the president made good use of the worthier of his advisors, he was a poor judge of men and a careless executive, trusting everyone and demanding only loyalty. Harding "liked politicians for the reason that he liked dogs," one friend observed, "because they were usually loyal to their friends." But his sense of blind loyalty left him open to exploitation. In the early months of 1923, the first disclosures of Albert Fall's "giveaways" of government oil reserves at Teapot Dome, Wyoming, and rumors of corruption in the attorney general's office caught the White House by surprise. Harding's initial instinct to protect his friends gave way in the last months of his life to the tragic realization, which he confided to Herbert Hoover, that he had been betrayed. The president did not live to suffer the full disclosures of the Teapot Dome Scandal. While on a speaking tour of the Pacific Northwest that summer, he was stricken and died on August 2 in San Francisco.

WARREN G. HARDING

Margaret Lindsay Williams
oil on canvas, circa 1923
136 x 99.5 cm. (53½ x 39¼ in.) NPG.66.21

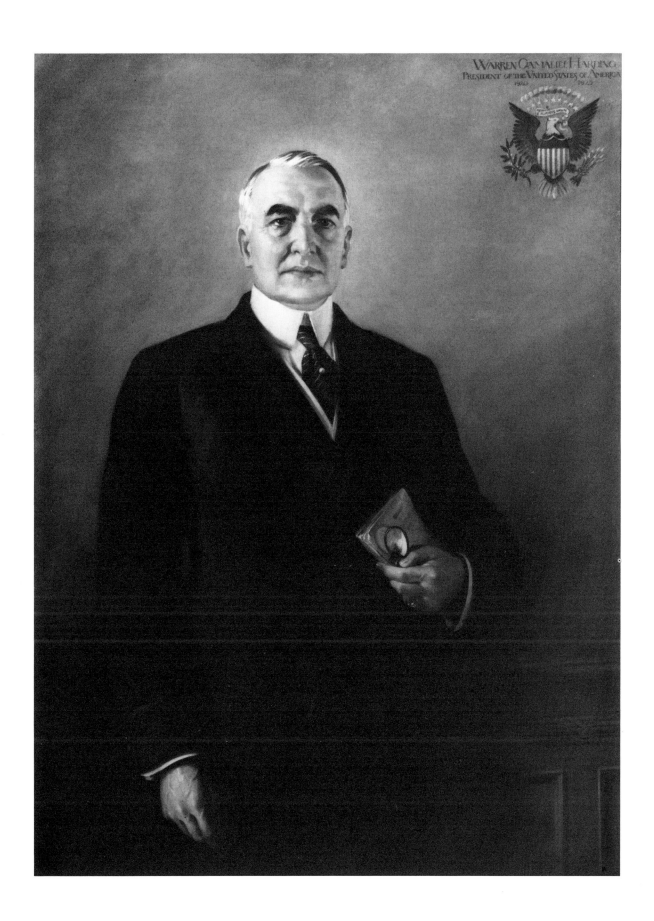

WARREN GAMALIEL HARDING
PRESIDENT OF THE UNITED STATES OF AMERICA
1921 1923

Calvin Coolidge

There is something monumental about the pose Calvin Coolidge struck for his portrait by Ercole Cartotto (copied by Joseph Burgess in 1956) during his final months in office. The grim rectitude, the formal dignity, the quiet determination suggest a man who stood for something. In fact, Coolidge stood for very little. Beneficiary of the nation's moment of peace and prosperity between World War I and the Great Depression, the president prided himself on what he did not do or say. "Perhaps one of the most important accomplishments of my administration," he announced at his last press conference, was "minding my own business."

Coolidge reached the presidency through luck. A diligent, unimaginative Massachusetts governor in 1919, he rose to prominence as the national symbol of law and order when he called out the state guard to end Boston's police strike. Coolidge found himself the vice-presidential nominee in 1920 and then, through an accident of fate, president in August 1923 after Harding's sudden death. A "Puritan in Babylon," according to his biographer, William Allen White, Coolidge enjoyed great popularity during the next five-and-a-half years because an expansive, giddy era valued his sober nature as a sop to old-time virtue. When he left office in the still-prosperous early spring of 1929, "Silent Cal's" luck held out. It was not until almost eight months later that the stock market collapsed and with it the fragile structure of his presidential legacy.

CALVIN COOLIDGE
Joseph E. Burgess after the 1929 oil by Ercole Cartotto
oil on canvas, 1956
143.5 x 97 cm. (56½ x 38¼ in.)
Gift of the Fraternity of Phi Gamma Delta NPG.65.13

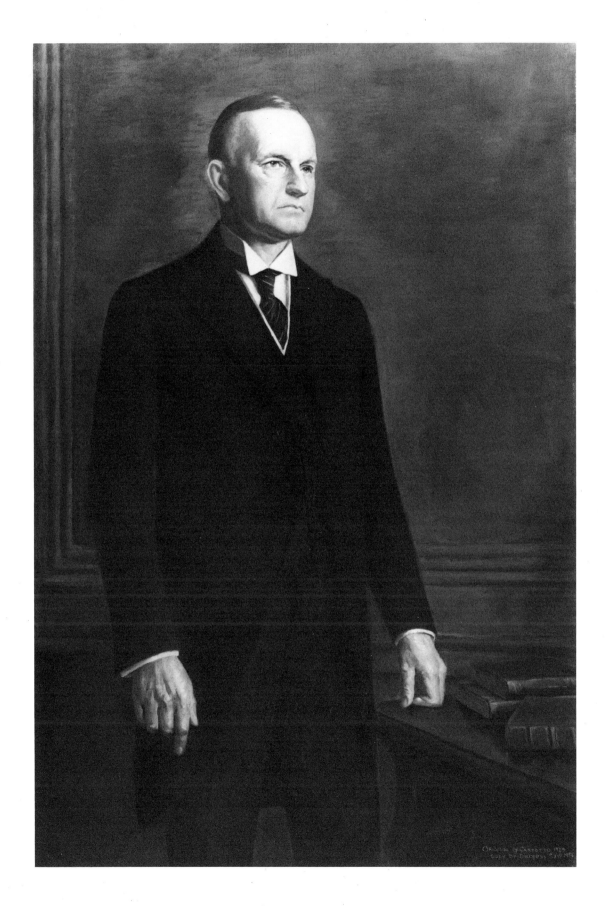

Herbert Hoover

31st PRESIDENT 1929–1933

In the spring of 1929, when Herbert Hoover was enjoying immense popularity as the guardian of American prosperity, *Time* magazine commissioned the English artist Douglas Chandor to portray the new president and his cabinet. It was not, however, until two years had passed, two of the bleakest in Hoover's life and in the economic life of the nation, that the president finally sat to Chandor—unchanged still in the phenomenal vigor of his administrative talents, unchanged in the fundamental compassion of his nature, but tragically changed as a symbol of national confidence.

Closely identified with the apparent health of the American economic system, Hoover—who had registered successive triumphs as an international mining engineer, as the "Great Humanitarian" of the European war relief efforts, and for eight years as secretary of commerce—was implicated in the collapse of that system. The president, despite his wholesale commitment to "rugged individualism," showed flexibility by instituting the first major federal programs of relief and economic stimulus; but his insistence on traditional principles in the face of deteriorating conditions and his reluctance to use a cure that he believed might prove worse than the disease was mistaken by increasing numbers of Americans for callousness. The electorate had chosen in 1928 a master engineer, but now demanded an economic savior. "This is not a showman's job," Hoover responded. "I will not step out of character." Defeated in the election of 1932 by a crushing margin, he went into exile in Roosevelt's America.

HERBERT HOOVER

Douglas Chandor
oil on canvas, 1931
114.5 x 96.5 cm. (45 x 38 in.) NPG.68.24

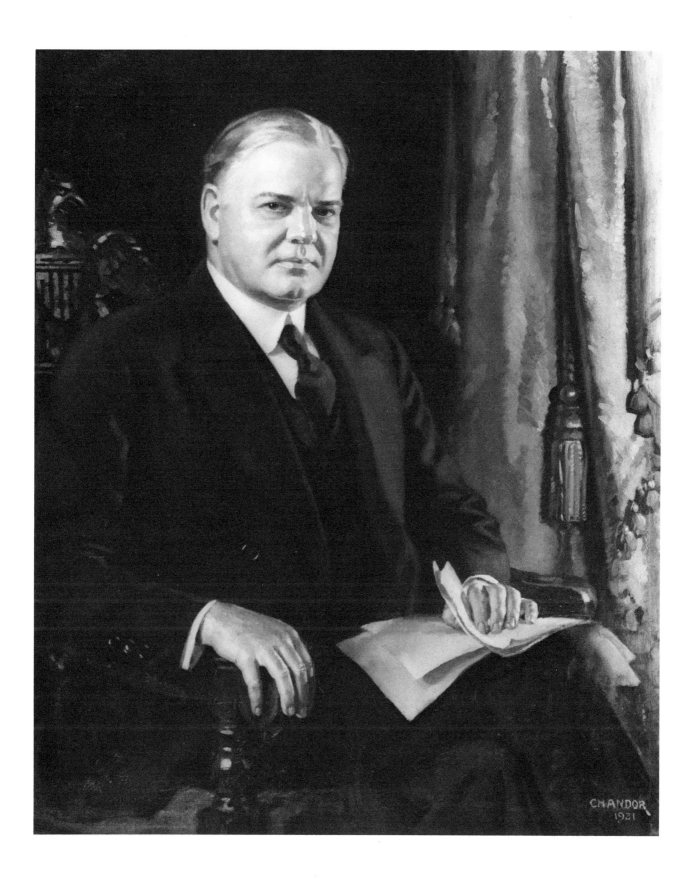

69

Franklin D. Roosevelt

32D PRESIDENT 1933–1945

During the three or four sittings Franklin Delano Roosevelt gave Douglas Chandor in March of 1945, shortly before his death, he grew disconcerted by the attention Chandor was paying to what FDR considered his unremarkable "working hands." But Chandor was the shrewder judge of the Roosevelt presence; it could truly be said of FDR that he had style and authority to his fingertips. In this oil study for the uncompleted *Big Three at Yalta*, to commemorate the conference to organize the postwar world, the artist painted a wan Roosevelt at the end of his vigorous life, firm in his gaze and elegant in his dress, but most like himself in the forceful expressiveness of his hands.

Roosevelt dominated his time because he attacked its disunity. Himself a blend of supposed contradictions—an urbane New Yorker with an understanding of agrarian America, an aristocrat who articulated social justice as a national ideal, a radical innovator who was deeply conservative in what he wanted to preserve, a man neither above politics nor trapped by its narrowest concerns—Roosevelt formed a coalition of urban workers and rural poor, of Northerners and Southerners, of whites and blacks, of pragmatists and idealists united by a once-eroded sense of national purpose. Even for those who stood angrily outside his coalition, Roosevelt remained, throughout his unprecedented twelve years in office during the depression and war, a preeminent force in the national life, a lightning rod for emotions about the meaning of America.

In the course of his active presidency, Roosevelt transmitted to a growing bureaucracy of federal agencies his sense of responsibility for the well-being of the citizenry and his own high, perhaps dangerously high, expectations for what might be achieved through good intentions and expert planning. When the war in Europe and Asia intruded on isolationist America, he mobilized the country, too eagerly some thought, and broadened his vision of American responsibility to include the creation of a world order. Throughout, Roosevelt held to his sense of the presidency as a place of moral leadership. "Where there is no vision," he said, "the people perish."

FRANKLIN D. ROOSEVELT
Douglas Chandor
oil on canvas, 1945
136.5 x 116 cm. (53¾ x 45¾ in.) NPG.68.49

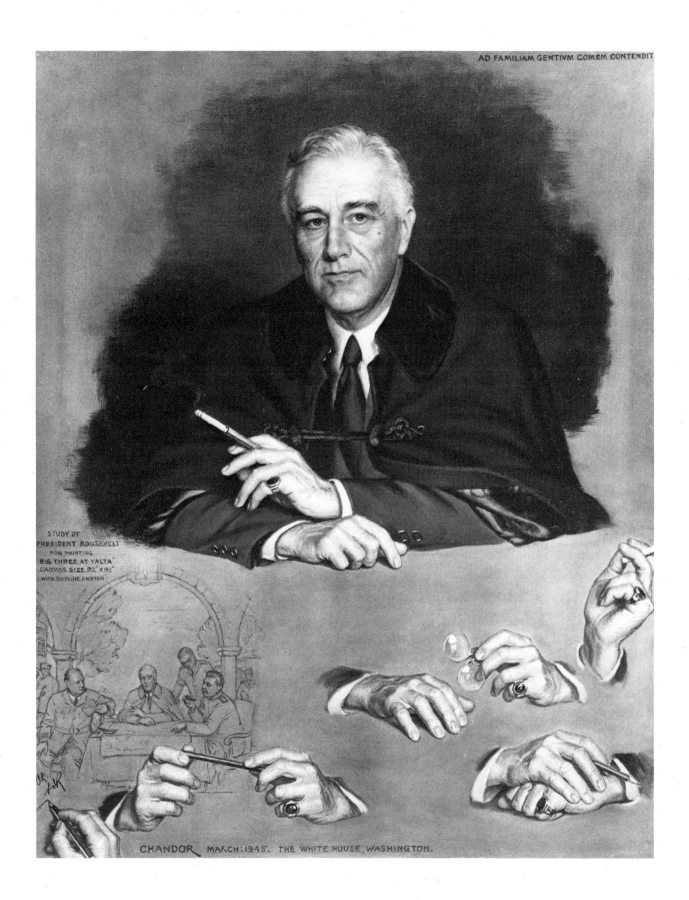

AD FAMILIAM GENTIVM COMEM CONTENDIT

STUDY OF
PRESIDENT ROOSEVELT
FOR PAINTING
"BIG THREE AT YALTA"
CANVAS SIZE 92" X 92"
WITH OUTLINE SKETCH

CHANDOR · MARCH·1945· THE WHITE HOUSE, WASHINGTON.

Harry S Truman

33ᴅ PRESIDENT 1945–1953

Of the two portraits of Harry S Truman begun by Greta Kempton in the fall of 1948, this one, completed only in 1970 for presentation to the National Portrait Gallery, is the more private portrayal of the man during that ominous, central year of his presidency. In the formal White House portrait, Truman sits resolute, already confident of success. Here we see him subdued and introspective, not so much posing for history as deeply immersed in it.

The collapse of Truman's popularity in 1948 reflected the national discouragement with a world gone sour. At home, the consensus of the New Deal had dissolved, after Roosevelt's sudden death, in squabbling between the new president and a Republican Congress, and in a series of rancorous strikes. Abroad, the supposed harmony of Yalta had turned into confrontation between America and the expanding communist world. Reelected against all odds, Truman rarely achieved support for his domestic programs, but the scope of his foreign policy initiatives was breathtaking. The man who had not hesitated to use the atomic bomb against Japan acted with comparable and controversial decisiveness to bolster anti-communist regimes in Greece and Turkey, to undertake an airlift against the Berlin blockade, and to launch a limited war against communist incursions in Korea. Faced with the disintegration of the European economies, he conceived and implemented the Marshall Plan in what Churchill called "the most unsordid act in history."

At the heart of Truman's power was his confident regard for what a single man might achieve. "I find that throughout our own history," he once said, "the greatest strides occur when courageous and gifted leaders either seize the opportunity or create it." And later: "I have tried to give it everything that was in me."

HARRY S TRUMAN

Greta Kempton
oil on canvas, 1948 and 1970
96.5 x 76 cm. (38 x 30 in.)
Gift of Dean Acheson, Thomas C. Clark, John W. Snyder, Robert A. Lovett,
Clinton P. Anderson, Charles F. Brannan, Charles Sawyer, W. Averell Harriman,
David K. E. Bruce, Edward H. Foley, Stuart Symington, William McChesney Martin,
Clark Clifford, Charles S. Murphy, Ward M. Canaday, and Joseph Stack NPG.70.11

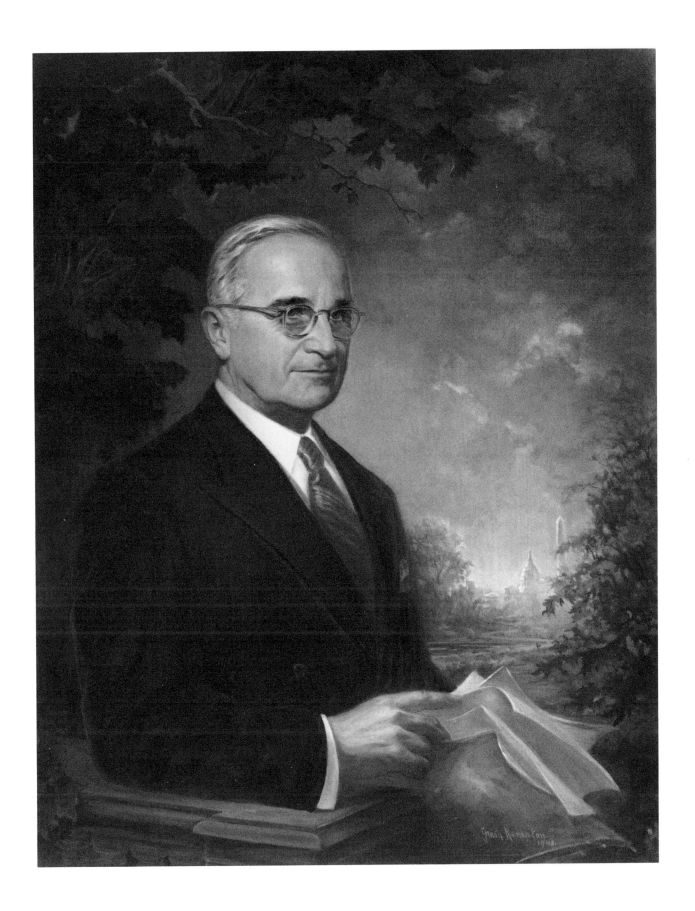

Dwight D. Eisenhower

34TH PRESIDENT 1953–1961

Dwight D. Eisenhower was particularly fond of this portrait, the second of twenty-four Thomas Stephens would paint of him. It is a warm portrayal of the then Army Chief of Staff, with the emblems of rank overshadowed by his quiet authority. Eisenhower was enjoying perhaps his happiest period, beginning two years before with his triumph as supreme commander of the Allied Forces in Europe, and ending in 1952 when he accepted the Republican nomination for the presidency.

Very unlike his two predecessors, Eisenhower was genuinely reluctant to assume the presidential role. Apolitical by instinct, he described himself, the year this portrait was painted, as "neither a Republican nor a Democrat" and finally accepted party and office only out of a sense of public duty. That very quality of political reserve appealed to an electorate tired of partisan bickering and continued to bolster his popularity through two terms. A fatherly figure of moderation in an anxious age, "Ike" waited out the tumult of Sen. Joseph McCarthy's anti-communist crusade with soft-spoken disapproval, and proceeded cautiously in support of the Supreme Court's epoch-making decision against school segregation. In foreign policy, his was the first administration to be preoccupied with the nuclear threat, balancing the deterrent of "massive retaliation" with a commitment to "atoms for peace."

Eisenhower was surrounded, wrote one contemporary, by "an atmosphere of uncomplicated goodness and uprightness," which satisfied a national nostalgia for simpler times. But the general did not dwell on an America that might have been. He began his administration as an international realist, warning in his inaugural address against a return to isolationism. And he ended as a worried prophet—witness, in his farewell address, to the growing menace of a national "military-industrial complex."

DWIGHT D. EISENHOWER
Thomas Edgar Stephens
oil on canvas, 1947
117 x 89 cm. (46 x 35 in.)
Transfer from the National Gallery of Art
Gift of Ailsa Mellon Bruce, 1947 NPG.65.63

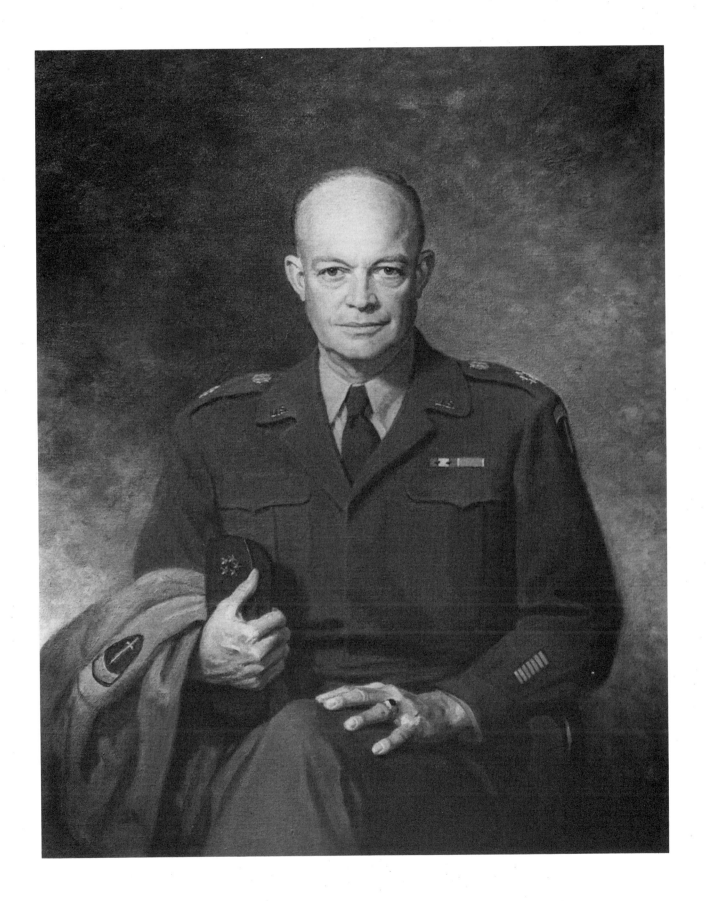

John Fitzgerald Kennedy

35TH PRESIDENT 1961–1963

John Fitzgerald Kennedy was a president who fascinated. No one like the brash, charming scion of a Massachusetts Irish Catholic dynasty of politicians and financiers had ever been seen in the White House. Yet the nation found it remarkably easy to identify with the young president. His popularity revealed a hitherto unsuspected yearning in America for style, for cosmopolitanism, and for refreshed idealism. From the moment of his memorable inauguration, JFK was a symbol of new possibilities.

But if the Kennedy years invigorated American society with a sense of public service and renewal—expressed abroad by the Peace Corps and at home by Martin Luther King's civil rights movement and triumphant march on Washington—they were also years of marked tension. Challenged by the extension of Soviet power, the president, who had stumbled badly in the ill-conceived Bay of Pigs invasion of Cuba, successfully forced the withdrawal of Russian missile bases from the island at the agonizing risk of atomic war, and pushed American convoys on to encircled Berlin. Through it all, he managed, by strength of personality, to hold the nation in a balance of anxiety and hope.

Kennedy's countrymen depended on him more than they realized. The president's look of competence and ease, which William Draper portrayed in 1962 and then in this replica of 1966, inspired confidence during the succession of international crises and even in the face of legislative setbacks for most of his reform measures. Kennedy's assassination in November of 1963 was an assault not only on the presidency, but on the self-assurance of a generation of Americans.

JOHN FITZGERALD KENNEDY
William Franklin Draper
oil on canvas, 1966, from the 1962 life sketch
101.5 x 81 cm. (40 x 32 in.) NPG.66.35

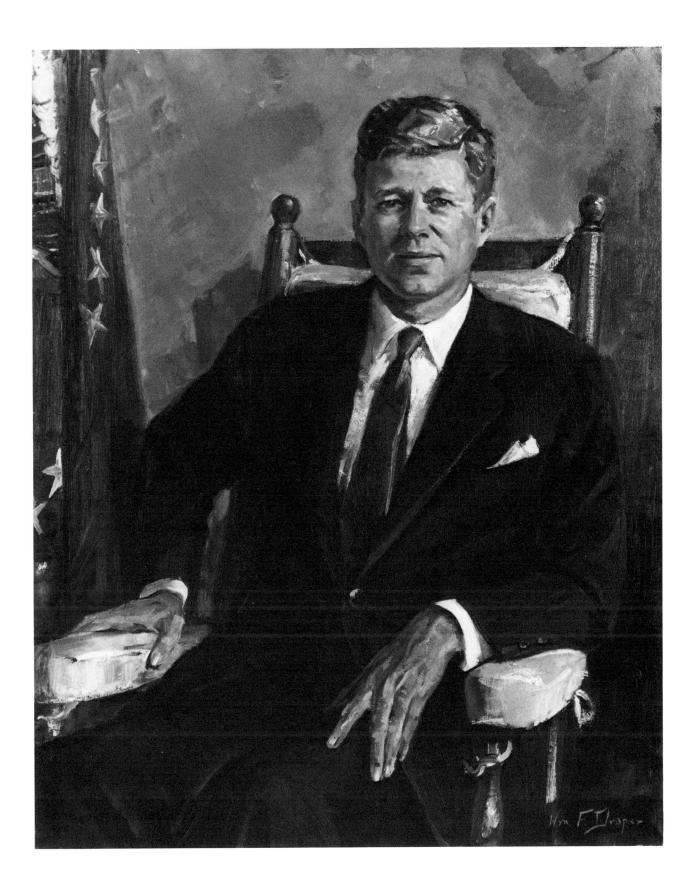

77

Lyndon Baines Johnson

36TH PRESIDENT 1963–1969

This likeness of Johnson was begun and then later completed at two high points of his career: in 1959, when he flourished as Senate majority leader, and in late 1963, when he masterfully conducted the government through its crisis transition after Kennedy's assassination. In personal style completely unlike his predecessor, the folksy president exerted his expansive Texan nature in the enactment of programs for social reform, promising the nation a future when all things were possible. He was rewarded in the 1964 election with a victory of historic proportions.

In time, however, Johnson became a victim of his own optimism. Convinced that America could not only mount a war on poverty at home but also wage full-scale war in Southeast Asia, he presided over a society overstrained by rising expectations and the pressures of mobilization for an unpopular conflict. Riots in the inner cities and militant peace marches came to characterize an administration the president had hoped would be marked by consensus. Finding himself unable to inspire trust, he resorted to angry exchanges with his critics. It was Johnson's bitter experience to be president in an era of frustration as Kennedy had been president in an era of hope.

LYNDON BAINES JOHNSON
Jimilu Mason
bronze, 1959 and 1963
50 cm. height (19⅝ in.)
Gift of the Brown Foundation, Inc., Houston, Texas NPG.72.72

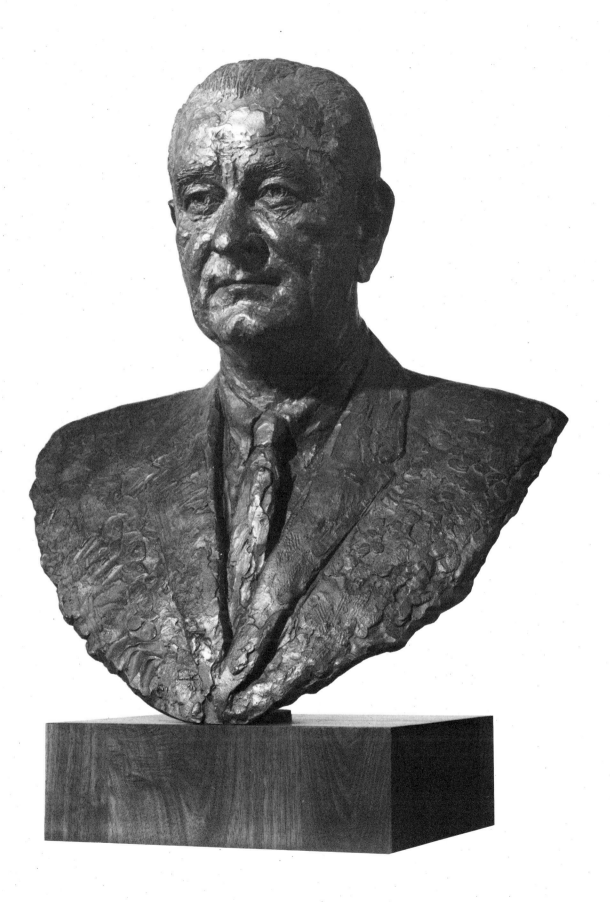

Richard M. Nixon

37th PRESIDENT 1969–1974

One of the most cryptic men to occupy the White House, Richard Milhous Nixon surprised first his political enemies, with the liberal direction of his foreign policy, and then his political friends, with the Watergate scandal which toppled his administration.

Nixon rose to national prominence as a combatant in the cold war struggle against communism. Elected a congressman from southern California in 1946, and a senator in 1950, he supported the House Un-American Activities Committee and took center stage in the prosecution of Alger Hiss, a former State Department official charged with communist affiliations. In 1952, he became the Republican Party's nominee for vice president, and occupied that office, under Eisenhower, through 1960.

Although defeated in his bid for the presidency by a narrow margin in 1960, Nixon salvaged what seemed like the remnants of his political career and emerged after years of fence-mending as the Republican nominee for president in 1968, when Norman Rockwell painted this portrait. In his first inaugural address, Nixon chose as the theme "Let Us . . . Go Forward Together" and asked for reconciliation among Americans over Vietnam and the race issue. Although bitterly attacked for his delay in ending America's commitment to the Vietnam War, Nixon did eventually preside over a withdrawal. Together with Secretary of State Henry Kissinger, he instituted a policy of détente with the communist regimes of China and the Soviet Union, ending the climate of cold war once so closely identified with his career.

Nixon's second term began in triumph, with a landslide victory in 1972, but ended abruptly. Growing public and congressional concern over the widening circle of responsibility for the burglary of the Democratic headquarters at the Watergate and the subsequent cover-up led to his resignation from office in August 1974.

RICHARD M. NIXON
Norman Rockwell
oil on canvas, 1968
46.5 x 66.5 cm. (18¼ x 26¼ in.)
Gift of the Richard Nixon Foundation NPG.72.2

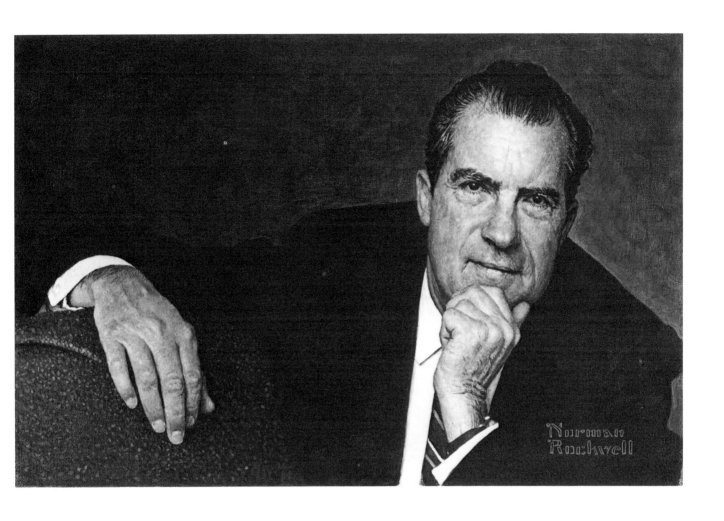

Gerald R. Ford

38TH PRESIDENT 1974–1977

Once described by a colleague as a man who would "rather be Speaker of the House than President," Gerald Ford became the thirty-eighth president of the United States as a result of the extraordinary constitutional circumstances produced by the Watergate crisis.

Ford had practiced law in Grand Rapids, Michigan, and in 1948 won election to the House of Representatives, where he earned a reputation as "a congressman's congressman." In 1965, he successfully challenged Charles A. Halleck for the office of House minority leader; in 1968 and 1972, he was permanent chairman of the Republican National Convention. During the Nixon presidency, Ford's voting record showed almost unswerving loyalty to the administration. When Spiro Agnew resigned the vice presidency in October 1972, Nixon chose Ford to serve in his place. When Nixon himself resigned on August 9, 1974, under threat of impeachment, Gerald Ford became the nation's first appointed president.

Within a month, Ford issued a "full, free and absolute pardon" to Richard Nixon. And although that action aroused a strong national outcry, Ford then worked to restore public confidence in the political system. "Our long national nightmare is over," he told the American people when he was sworn in. "Our Constitution works. Our great republic is a government of laws and not of men."

GERALD R. FORD
Photograph courtesy of the White House

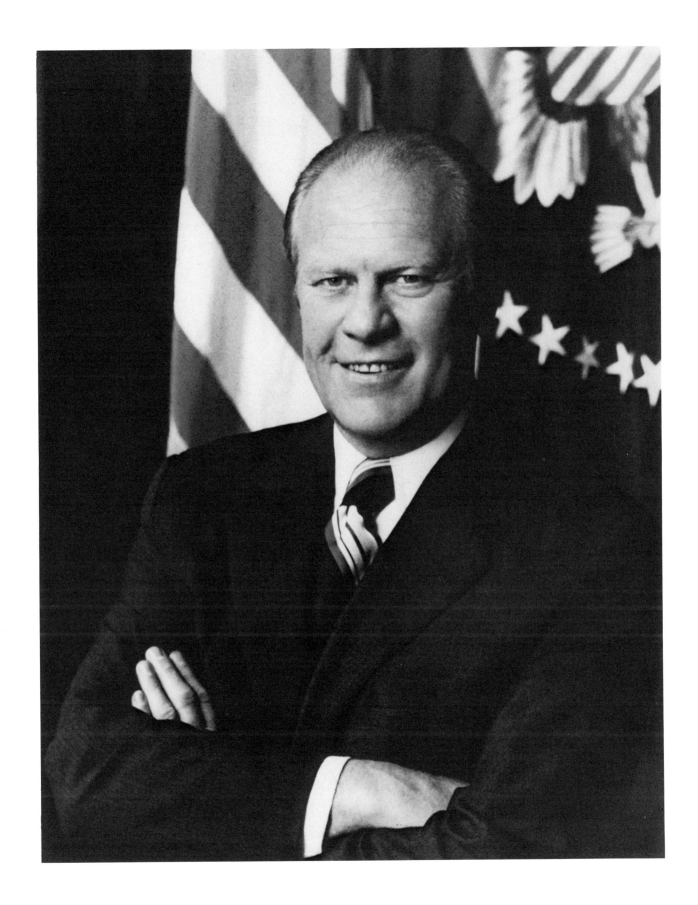

Jimmy Carter

Jimmy Carter of Plains, Georgia, seemed at first like a candidate from an outdated America, with his small-town origins, his agrarian concerns, his insistence on traditional values. But Carter invested the old formula with new meaning: the peanut farmer was a successful modern businessman and one-time nuclear engineer, and the spokesman for a fundamental morality showed an urban understanding of modern problems. Even the inevitable politician's smile he customarily flashed could suggest a surprising originality of feeling and then settle suddenly, as in this Jamie Wyeth sketch of the president-elect in Plains, into a mood of honest introspection.

The phenomenon of Carter's candidacy and election in the late 1970s promised, in an era of dissonance, that the old values and the new realities might coexist. Stepping outside the polarities of American political life, Jimmy Carter also showed finally that a Southerner might value both his heritage and the civil rights of all Americans, and that a Democratic liberal, with a proven social conscience, might embrace fiscal conservatism. An outsider on the national scene, the one-time governor of Georgia offered the hope of a presidency that could at once heal and redefine American society.

JIMMY CARTER
Jamie Wyeth
pencil on paper, 1976
20.3 x 28 cm. (8 x 11 in.)
Gift of Martin Peretz NPG.77.21

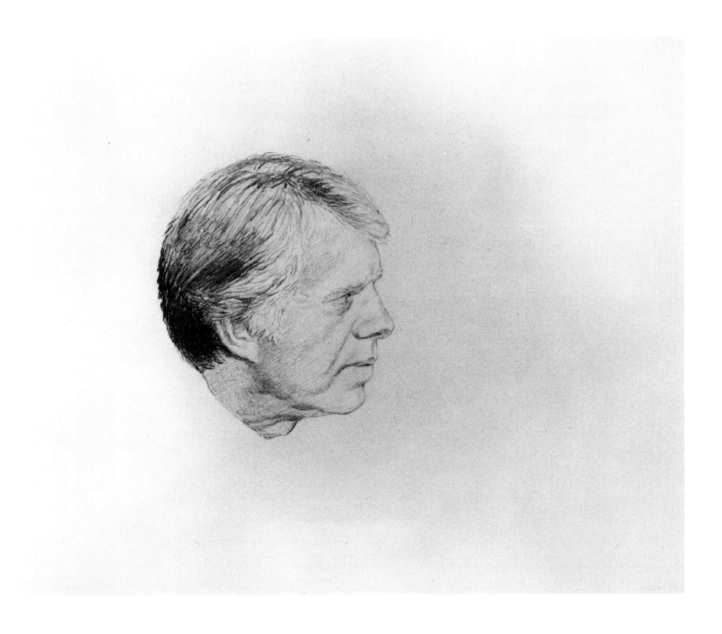

Chronologies

George Washington 1732–1799

1775 Became commander-in-chief of the Continental Army
1787 Presided over federal Constitutional Convention
1789 Unanimously chosen first president
1792 Reelected president
1793 Issued proclamation of neutrality in war between France and England
1794 Whiskey Rebellion suppressed
1795 Jay Treaty upheld
1797 Farewell address

John Adams 1735–1826

1776 Appointed to committee to prepare Declaration of Independence
1783 With Benjamin Franklin and John Jay, negotiated Paris peace treaty with Great Britain
1785 Appointed first American minister to the Court of St. James's
1789 Elected vice president
1792 Reelected vice president
1796 Elected president
1798 Signed Alien and Sedition Acts

Thomas Jefferson 1743–1826

1776 Appointed to prepare Declaration of Independence
1785 Published *Notes on the State of Virginia*
1790 Appointed secretary of state
1796 Elected vice president
1801 Elected president by House of Representatives after electoral tie
1803 Initiated Lewis and Clark Expedition; Louisiana Purchase transacted
1804 Reelected president

| 1807 | Enacted embargo against British trade |
| 1814 | Drafted plan for University of Virginia |

James Madison 1751–1836

1787	Served as leading advocate for Constitution at federal convention
1789	Sponsored Bill of Rights in House of Representatives
1801	Appointed secretary of state
1808	Elected president
1812	War message to Congress; reelected president
1816	Signed bill creating Second National Bank of the United States

James Monroe 1758–1831

1798	Elected governor of Virginia
1811	Appointed secretary of state
1816	Elected president
1820	Reelected president, without opposing candidate
1823	Monroe Doctrine message to Congress

John Quincy Adams 1767–1848

1814	Served as peace commissioner at Ghent for negotiations ending War of 1812
1817	Appointed secretary of state
1824	Elected president
1830	Elected to House of Representatives
1841	Successfully defended slave mutineers of *L'Amistad* before Supreme Court

Andrew Jackson 1767–1845

1815	Defeated the British at Battle of New Orleans
1821	Appointed first governor of Florida Territory
1824	Received plurality of electoral vote for presidency, but lost election in House of Representatives
1828	Elected president
1832	Vetoed bill to recharter Bank of the United States; reelected president; issued Nullification Proclamation to people of South Carolina

Martin Van Buren 1782–1862

1828 Elected governor of New York
1829 Appointed secretary of state
1831 Appointed minister to Great Britain
1832 Elected vice president
1836 Elected president
1837 Panic of 1837
1840 Signed Independent Treasury Act; renominated for presidency but lost

William Henry Harrison 1773–1841

1801 Appointed governor of Indiana Territory
1811 Defeated Indians at Tippecanoe
1824 Elected to Senate
1840 Elected president
1841 Died in office

John Tyler 1790–1862

1825 Elected governor of Virginia
1827 Elected to Senate
1840 Elected vice president
1841 Succeeded Harrison as president
1844 Negotiated treaty for annexation of Texas

James K. Polk 1795–1849

1835 Selected Speaker of the House of Representatives
1839 Elected governor of Tennessee
1844 Elected president
1846 Declared war against Mexico; concluded treaty with Great Britain establishing
 Oregon boundary on forty-ninth parallel
1848 Treaty of Guadeloupe–Hidalgo signed, ending Mexican War

Zachary Taylor 1784–1850

1832 Led forces in Black Hawk War
1846 Brevetted brigadier general for distinguished service in Mexican War

1848	Elected president
1850	Passed measures constituting Compromise of 1850; died in office

Millard Fillmore 1800–1874

1832	Elected to House of Representatives
1848	Elected vice president
1850	Succeeded Taylor as president; Fugitive Slave Law enacted
1852	Sent Commodore Matthew C. Perry to open Japan to trade

Franklin Pierce 1804–1869

1836	Elected to Senate
1847	Commissioned brigadier general in Mexican War
1852	Elected president
1854	Signed Kansas–Nebraska Act; Gadsden Purchase treaty

James Buchanan 1791–1868

1845	Appointed secretary of state
1856	Elected president
1857	Dred Scott Decision
1861	Secession of Mississippi, Florida, Alabama, Georgia, Louisiana, and Texas

Abraham Lincoln 1809–1865

1846	Elected to House of Representatives
1858	Lincoln–Douglas debates
1860	Elected president
1861	Civil War began
1863	Issued Emancipation Proclamation; delivered Gettysburg Address
1864	Reelected president
1865	Assassinated shortly after the South surrendered

Andrew Johnson 1808–1875

1857	Elected to Senate
1862	Appointed military governor of Tennessee
1864	Elected vice president

1865 Succeeded Lincoln as president
1867 First, Second, and Third Reconstruction Acts passed despite presidential veto
1868 Acquitted at impeachment trial before Senate

Ulysses S. Grant 1822–1885

1863 Named general of Union armies in West
1864 Given supreme command of Union forces
1865 Received Lee's surrender at Appomattox, Virginia
1868 Elected president
1872 Signed Amnesty Act restoring civil rights to most Southerners; reelected president
1873 Panic of 1873

Rutherford B. Hayes 1822–1893

1864 Elected to House of Representatives
1867 Elected governor of Ohio
1876 Elected president
1877 Ended military reconstruction of South

James A. Garfield 1831–1881

1863 Promoted to major general of volunteers; resigned from army to take seat in
 House of Representatives
1880 Elected president
1881 Assassinated

Chester A. Arthur 1830–1886

1871 Appointed collector of port of New York
1880 Elected vice president
1881 Succeeded Garfield as president
1883 Signed Pendleton Act, which provided foundation for reform of federal Civil
 Service

Grover Cleveland 1837–1908

1882 Elected governor of New York State
1884 Elected president

1887	Signed Interstate Commerce Act
1892	Elected president
1893	Financial panic
1894	Dispatched federal troops to curb Pullman strike

Benjamin Harrison 1833–1901

1880	Elected to Senate
1888	Elected president
1889	Pan American Conference
1890	Signed Sherman Anti-Trust Act and Sherman Silver Purchase Act

William McKinley 1843–1901

1876	Elected to House of Representatives
1891	Elected governor of Ohio
1896	Elected president
1898	Declared war against Spain
1900	Reelected president
1901	Assassinated

Theodore Roosevelt 1858–1919

1895	Appointed police commissioner of New York City
1898	Organized "Rough Riders" regiment
1900	Elected vice president
1901	Succeeded McKinley as president
1904	Panama Canal zone acquired by the United States; elected president
1905	Russo–Japanese Peace Treaty signed at Portsmouth, New Hampshire
1912	Organized Progressive party; defeated as its presidential candidate

William Howard Taft 1857–1930

1901	Appointed governor-general of Philippine Islands
1904	Appointed secretary of war
1908	Elected president
1913	Sixteenth Amendment adopted, giving Congress power to collect income tax
1921	Appointed chief justice of the United States

Woodrow Wilson 1856–1924

1902 Became president of Princeton University
1910 Elected governor of New Jersey
1912 Elected president
1913 Signed Federal Reserve Act
1914 Federal Trade Commission established
1917 United States declared war against Germany and Austria–Hungary
1918 Outlined his "Fourteen Points" to Congress; armistice signed
1919 Treaty of Versailles signed; Prohibition amendment ratified
1920 Women's Suffrage amendment ratified

Warren G. Harding 1865–1923

1914 Elected to Senate
1920 Elected president
1921 Signed first restrictive immigration act; opened Washington Conference for naval
 limitation
1923 Died in office

Calvin Coolidge 1872–1933

1918 Elected governor of Massachusetts
1920 Elected vice president
1923 Succeeded Harding as president; Teapot Dome oil scandal of Harding adminis-
 tration was revealed in Senate investigation
1924 Elected president

Herbert Hoover 1874–1964

1914 Chairman of American Relief Committee in London
1917 Appointed United States food administrator
1921 Appointed secretary of commerce
1928 Elected president
1929 Stock market collapse
1932 Reconstruction Finance Corporation established; defeated for reelection to presi-
 dency

Franklin Delano Roosevelt 1882–1945

1928 Elected governor of New York

1932 Elected president

1933 "Hundred Days" enactment of New Deal recovery measures; Prohibition amendment repealed

1935 Signed Social Security Act

1936 Reelected president

1940 Elected for a third term as president

1944 Dumbarton Oaks Conference established United Nations; elected president for a fourth term

1945 Attended Yalta Conference; died in office

Harry S Truman 1884–1972

1934 Elected to Senate

1944 Elected vice president

1945 Succeeded Roosevelt as president; ordered first atomic bomb dropped on Hiroshima, Japan

1946 Atomic Energy Commission created

1948 Elected president

1949 Signed North Atlantic Treaty ratification

1950 Ordered first American ground troops into Korea

Dwight D. Eisenhower 1890–1969

1943 Appointed supreme commander, Allied Expeditionary Force

1950 Commander of North Atlantic Treaty Organization forces in Europe

1952 Elected president

1953 Korean War ended

1954 Supreme Court declared racial segregation in schools unconstitutional

1956 Reelected president

1958 National Aeronautics and Space Administration established; launching of first American satellite

John Fitzgerald Kennedy 1917–1963

1943 Given command of PT 109; held rank of lieutenant in Navy; awarded Purple Heart for heroism in World War II

1952 Elected to Senate

1955 Wrote *Profiles in Courage* (Pulitzer Prize, 1957)

1960 Elected president

1961 Created Peace Corps by executive order; Bay of Pigs invasion of Cuba; first United States manned space flight

1962 Cuban missile crisis

1963 Civil rights march on Washington, D.C.; assassinated

Lyndon Baines Johnson 1908–1973

1948 Elected to Senate

1955 Chosen Senate majority leader

1960 Elected vice president

1963 Succeeded Kennedy as president

1964 Signed Civil Rights Bill; elected president; Gulf of Tonkin resolution passed allowing greater involvement of United States in Southeast Asia war

1965 Watts riot

1968 Assassinations of Martin Luther King and Robert Kennedy

Richard M. Nixon 1913–

1950 Elected to Senate

1952 Elected vice president

1956 Reelected vice president

1961 Wrote *Six Crises*

1968 Elected president

1969 Began withdrawal of American troops from South Vietnam

1972 Watergate break-in; reelected president; overture to People's Republic of China

1973 Watergate hearings resulting in conviction of many White House aides; resignation of Vice President Spiro Agnew

1974 Resigned from office

Gerald R. Ford 1913–

1948 Elected to House of Representatives

1965 Chosen House minority leader

1973 Appointed vice president upon resignation of Agnew

1974 Became president upon resignation of Nixon; pardoned former President Nixon

Jimmy Carter 1924–

1970 Elected governor of Georgia

1976 Elected president

1978 Camp David summit meeting to initiate peace settlement in Middle East; Civil Service Reform Act signed by president; announced recognition of People's Republic of China